# HIDDEN
# HISTORY
*of*
# PORTLAND
# OREGON

# HIDDEN
# HISTORY
## *of*
# PORTLAND
# OREGON

JD CHANDLER

THE
History
PRESS

Published by The History Press
Charleston, SC 29403
www.historypress.net

First published 2013

Manufactured in the United States

ISBN 978.1.62619.198.3

Library of Congress Cataloging-in-Publication Data

Chandler, J. D.
Hidden history of Portland, Oregon / JD Chandler.
pages cm. -- (Hidden history)
ISBN 978-1-62619-198-3 (pbk.)
1. Portland (Or.)--History--Anecdotes. 2. Portland (Or.)--Biography--Anecdotes. I. Title.
F884.P857C53 2013
979.5'49--dc23
2013040954

*The debt that each generation owes to the past it must pay to the future.*
—Abigail Scott Duniway

# CONTENTS

# WHY IS IT HIDDEN HISTORY?

Portland has a two-faced history. On the one hand is the official story of the Rose City: growth and development under the leadership of a selfless group of merchant city fathers and rivalry for economic domination with other West Coast cities. On the other hand is the experience of the people who lived here: economic displacement, government dominated by corruption, graft and racial discrimination and resistance against the dominant system. The history of Oregon in the nineteenth century revolves around two bankrupt ideas: male dominance and white supremacy. In many ways, the history of our state, especially in the twentieth century, has been a struggle against these ideas. The history of the twenty-first century continues this struggle.

This book is history hidden in plain sight: fully documented in our archives, yet never told or, at best, hinted at in our history books. In a sense, it is a people's history of Portland: an attempt to tell the story of the people who have lived on this spot, where two great rivers meet, for thousands of years. It is history for everyone. My hope is that, regardless of your background or experience, you will find someone here who looked like you, and their lives and experience will have meaning in your life. This is how history can live.

W.E.B. Dubois, one of America's best historians, said that we don't talk about black history in this country because we are ashamed of it. That is the history that interests me: the history we are ashamed of, the history we have been too polite to mention and have forgotten. Join me now as I open the crowded, dusty closet of Portland's history and examine the skeletons

bone by bone. Shameful history is not only the most interesting, but it also gives us the best chance to see how real people have dealt with injustice and oppression. Most of all, it is fun. Thanks for reading.

As always, errors and opinions in this book are my sole responsibility, but I am indebted to many friends and family who have lent their support and assistance. Thanks to Margaret H. Akbari, Barney Blalock, Steve Chandler, Carie Eisler, Ken Goldstein, Jim Huff, Finn J.D. John, John Klatt, Aubrie Koenig, Jacqueline Lawson, Sam Leighton, Tim Rich, Leslie Sand, Nancy Stewart and Jake Warren. In addition, there have been several institutions and organizations that have provided valuable assistance: the Ben Holladay Society, Multnomah County Library, Old Oregon Photos, Oregon Nikkei Center, Portland City Archive, Portland Maritime Museum, Portland Police Museum, Oregon State Archives and the U.S. Library of Congress.

# PART I
## *Oregon Versus Ilahee*

# BEFORE PORTLAND

*Did not your missionaries teach us that Christ died to save his people? So die we to save our people.*
*—Tiloukaikt of the Cayuse Five*

Most histories of Portland ignore the fact that people have lived at the confluence of the Willamette and Columbia Rivers for as many as ten thousand years. They are able to do this because the waves of disease that passed through the Indian villages between 1815 and 1840 reduced their population from an estimated eleven thousand to just a few hundred. Waves of smallpox, measles, tuberculosis and malaria combined with environmental change caused by the fur trade and the efforts of settlers to establish Western-style agriculture in Oregon not only killed off the majority of the first Oregonians but also endangered native ways of life and put intense pressure on native cultural values and institutions that the people depended on for their survival.

The area where Portland was built in the 1840s was a meeting place for three distinct native cultures: Chinook, Kalipuya and Sahaptian. The Clearing, as the Portland town site was originally known, halfway between the important fishing grounds of Cascade Locks on the Columbia and Willamette Falls, was an important stopping place for canoes traveling between these sites. Historian Gray Whaley uses the *Chinook wawa* word *Illahee* (homeland) as the name for the complex web of Indian cultures, languages and family ties that existed before it was replaced by the Euro-

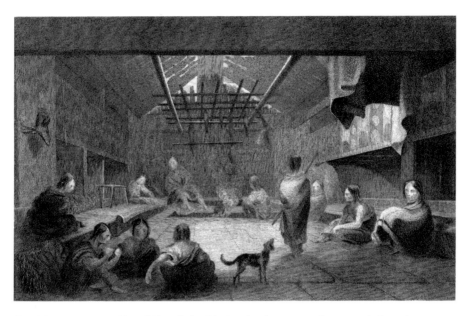

The Multnomah-speaking Chinook lived in bands of twenty to forty people in cedar longhouses along the south bank of the Columbia River. Drawing by Alfred Agate. *Courtesy of Old Oregon Photos.*

American concept of *Oregon. Illahee* was populated by autonomous bands, usually made up of family groups, designated by the language they spoke, who traveled on regular routes during the seasons in order to gather food and other resources. Most of the native bands depended on trading with other natives in order to secure luxuries and other desirable goods.

Language diversity was intense, with each language being divided into mutually unintelligible local dialects, causing problems of communication, cultural isolation and difficulties with trade. In response to the large diversity of language, *Chinook wawa*, a pidgin-style trade jargon made up of words from many languages, developed as the mutual trade language that dominated the region even after the coming of the Euro-American settlers. *Chinook wawa*, although limited in expressing complex ideas, provided a method for natives to trade with one another, and soon trade networks, usually based on family ties between linguistic groups, developed that brought goods from far north and south and east to the Great Plains.

The mouth of the Willamette River was dominated by Multnomah-speaking Chinook who lived in year-round villages made up of cedar longhouses. Several of these villages were situated on Sauvie's Island and

other strategic spots along the confluence of the Willamette and Columbia. The Willamette itself was dominated by Chinook Clackamas-speakers and Kalipuya bands speaking Tualatin and Yamhill languages. The Kalipuya traveled great distances at different seasons in order to gather food and other resources, but they usually wintered in underground lodges built near the Willamette River. Sahaptian bands, especially the Klickitat from the north side of the Columbia, also traveled to the Willamette seasonally for fishing and other food gathering. The Sahaptians, such as Nez Perce, Cayuse and Yakama, were the most nomadic of the native bands. Most Sahaptian tribes lived on the arid Columbia Plateau and were forced to travel great distances during the year in order to find enough food. The horse was introduced to the Pacific Northwest in the seventeenth century by the warlike Shoshone of the Snake River Valley, who traveled as far as Mexico in their yearly rounds and so had early contact with the Spanish. The introduction of the horse had a huge impact on the Sahaptians of the Columbia Plateau, extending the range of their travels and giving them an important military advantage. The Nez Perce, among other bands, regularly traveled over the Rocky Mountains, and their culture was greatly influenced by the Indians of the Great Plains. Guns followed the horses by a few decades, and warfare became fairly common in the northwest.

The cultures of the first people who inhabited the Portland area differed considerably. For example, the Chinook had a complex class-based society dependent on slavery and a wealthy upper class. They practiced "head-flattening," in which they strapped boards to the heads of infants in order to produce a distinctive skull shape that was much favored by the upper class. The Chinook enjoyed a rich abundance of food, especially salmon, and developed great skill at woodcarving and working with hides. The industrious people produced items such as *clatsop* (a popular food made from dried salmon and huckleberries similar to pemmican), *clamon* (heavy elk-skin garments that could stop arrows or even pistol bullets) and water-resistant hats made of basketry. Products such as these and slaves were the basis for Chinook trading that brought them a great deal of wealth.

The wealth of the Chinook created cultural institutions such as *potlatch*, a form of ritual gift giving by which the prosperous spread their wealth among the community. Gift giving was a very important element of Indian culture in the northwest. Through gift giving, the wealthy were able to fulfill responsibilities to less prosperous members of their bands, achieve social stability and make contact with other bands. In some bands, trade was

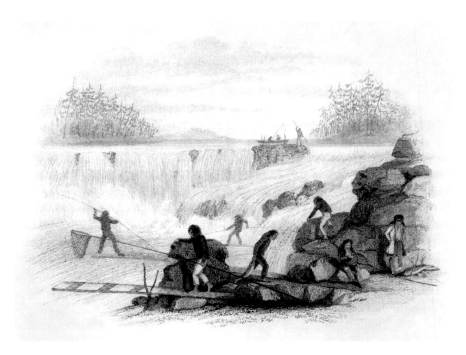

The Willamette Falls was an important fishing site where many different tribes congregated to harvest salmon, trade goods and share stories. The Indians adopted useful elements of Euro-American culture; for example, in this drawing, made in 1840, the Native Americans are wearing western-style clothes. Drawing by Joseph Drayton. *Courtesy of Old Oregon Photos.*

really just a mutual process of gift giving, a fact that led to many cultural misunderstandings with European and Euro-American traders, explorers and settlers.

Bands of Tualatin- and Yamhill-speaking Kalipuyans lived near the valleys of the similarly named rivers that feed the Willamette and gathered with the Multnomah, Clackamas, Klickitat and other bands at the Willamette Falls for the annual salmon harvest. The Kalipuya of the lower Willamette were heavily influenced by their proximity to the Chinook, and head-flattening and slavery were popular. The Kalipuya class system was not as rigid as that of the Chinook, and their lifestyle was more nomadic. Kalipuya bands would travel great distances during the spring, summer and fall and then gather together in villages during the winter. Their winter homes were built mostly underground, and they developed woodcarving and basket making to a high level.

Many different Sahaptian bands traveled to the Willamette Valley on their yearly rounds, but the main ones in the Portland area were Klickitat, from the mountains north of the Columbia River and closely related to the Yakama. Sahaptian cultures tended to be more individualistic than Kalipuya or Chinook, and they prized their independence highly. Sahaptians participated in the slave trade, taking prisoners during war to sell to Chinook traders, but slavery was not a strong part of their culture. They developed a complex, classless society based on mutual obligation to relatives, trading partners and friends that did not rely on authority such as chiefs, judges or police.

Despite these cultural differences, the first people of the lower Willamette shared some important things. Most importantly, the people who lived in the area where Portland is now gained great reputations as traders, especially the Klickitat, whom early Oregon pioneers referred to as "native Yankee traders." Salmon and camas root, the two main staples of the native diet, provided good nutrition and a spiritual focus for the religion of the native people. Both foods were seen as gifts from the earth that could be taken away if the people did not practice correct behavior. Correct behavior comes from the idea known by the Walla Walla as *tamánwit*, a complex idea that includes the belief that the earth is our mother and must be protected and cherished and that the way the creator made the world, and where he placed people, is important to the proper balance of life. *Tamánwit* also includes a concept of natural law and proper behavior. Each native language had its own word for this concept, but the basic belief was widespread. Another concept, known by the Walla Walla as *tewatat* or "medicine doctor tradition," recognizes the responsibility of doctors for healing the sick and demands the death of the doctor if he should fail. This idea was also widespread and lead to severe conflict with the Euro-American settlers who began to flood into the area in the 1830s.

The trans-Pacific trade impacted the lower Columbia/Willamette region long before European explorers came here. By the time Lewis and Clark's Corp of Discovery visited the region in 1805, blue Chinese beads known as *tia Commashuck* (chief beads) were well known and had replaced the dentalia (abalone shell) currency originally used by the Indians. Although Spanish and English explorers had mapped much of the Oregon coast before the eighteenth century, the first European traders to come to the area were Russian fur trappers searching for sea otter and beaver pelts. English, French *metis* and Euro-American trappers, known as mountain men, crossed over the Rockies at the end of the eighteenth century, and soon the British dominated the fur trade in the area. The fur trade brought environmental

change, as the beaver were hunted nearly to extinction, changing the shape and flow of the rivers. The fur trade also brought disease. When Lewis and Clark arrived, they found the Clatsop and other Chinook tribes had already been introduced to diseases such as syphilis.

Fort Astoria was built in 1811 as an American fur trading post, becoming the first Euro-American settlement in the Oregon Country. The population of Astoria was very diverse, including Euro-Americans, British, French, Kanaka (Hawaiians), Iroquois trappers and even Japanese at one point. Duncan McDougall, first commander of Fort Astoria, maintained mostly friendly relations with local Indians, marrying the daughter of the Multnomah headman, and thus becoming a "real" person in *Illahee* through family connection. Astoria became a source of disease for the Indians, though, bringing measles, smallpox and venereal disease. Fort Astoria became a focus for some of the earliest activity of the Prophet Movement that would sweep *Illahee* before the end of the century. Between 1812 and 1814, the prophet Kauxuma-nupika (Gone to Spirits), a Kutenai woman from the upper Columbia Plateau who underwent a spiritual sex change, traveled the Columbia River telling of her prophetic dreams of the coming of the white men. This was one of the earliest examples of the prophecies that attempted to explain the changes that were happening in the native world and led to a religious revival in the 1850s that helped to solidify native resistance to the Euro-American settlements and created the Dreamer Religion.

Native traders benefitted from the competition between "King George men" and "Bostons," sometimes choosing sides, sometimes playing the rivals off against each other in order to get better prices. The War of 1812 brought British occupation to Astoria and set the Hudson Bay Company (HBC) up to become the dominant trading entity in the region. HBC established forts, such as Vancouver, Nez Perce (Walla Walla) and Colville, to serve as trading posts and to provide support and protection for trappers in the area. The HBC expanded greatly in the 1820s, establishing Oregon City in 1829, following a policy of trapping beaver to extinction in order to create a "fur desert" that would discourage American emigration into the region. Although there were military clashes between HBC and native people, the company attempted to keep relations peaceful by fitting their operations into the native way of life as much as possible. It became common practice for HBC employees to take native wives, partly out of loneliness and partly because family relationships were the basis of economic and social functions among the natives. Intermarriage led to a large population of "half breeds" who played an important role in the early days of Oregon.

By the 1890s the native population of Oregon had been reduced to a tiny fraction of its former number. Westernization, begun by the Christian missionaries of the 1830s, was institutionalized in such facilities as the Chemawa School, a boarding school for young Indians. Photographer unknown. *Courtesy of Old Oregon Photos.*

In the 1830s, American missionaries began to arrive in the Oregon Country, starting with Jason Lee, who in 1834 established a Methodist mission where the city of Salem is now. The Oregon missions were an expression of two historical ideas that were sweeping the young United States: the religious movement known as the Great Awakening, and the political movement known as Manifest Destiny. Ostensibly founded to "save the Indians," the missions were the vital first wave of what became the Great Migration into the Oregon Country. Arriving at the height

of the malaria epidemic known as "Cold Sick" that was devastating the Willamette Valley, Lee and other missionaries found themselves struggling to survive in an isolated land full of sick, dying and despondent Indians. The Methodist Church established several missions in the Oregon Country between 1834 and 1841, including the Clatsop mission and the Wascopam mission near Celilo Falls on the Columbia. The American Board of Commissioners for Foreign Missions (ABCFM) founded several missions as well, including Marcus Whitman's mission at Waiilatpu on Cayuse land.

The missions were notably unsuccessful at converting Indians to Christianity or "saving" them in any other way, but they were successful at two things: popularizing the idea that the Indians would soon be extinct and creating huge interest in Oregon back in "the States." Marcus Whitman, the missionary to the Cayuse, was especially influential in motivating emigration. In 1838, he led a party over the new Oregon Trail that included his wife, Narcissa, and five other women, popularizing the idea that families could travel to the new country together. In 1843, he led a large party on the Oregon Trail. That year, more than nine hundred Euro-American settlers would come into the Oregon Country. Whitman more or less gave up on ministering to the Indians; his focus was on the new white settlers. In 1846, the Oregon Treaty with Great Britain recognized U.S. sovereignty over what would become the states of Oregon, Washington and Idaho, and the emigration trickle turned into a flood.

The natives were friendly and welcoming to the missionaries at first, and many of them allowed their children to be educated in Western-style agriculture and Christian faith at the mission schools. The high mortality rate of children in the mission schools, however, combined with the patronizing and arrogant attitudes of the missionaries, soon made the natives turn away. The Western-style medicine that the missionaries brought with them at first attracted the natives, but its failure to cure the diseases that were ravaging their communities soon came into conflict with the native idea of "medicine doctor tradition." Marcus Whitman, a doctor, was disgraced in the eyes of the Cayuse because he was unable to cure their children from diseases such as measles, which killed the young Cayuse at a high rate.

In addition, the natives were alarmed at the increasing numbers of Euro-American settlers on their land. Agricultural efforts by the settlers reduced the land where camas root grew and competition for fish on the rivers led to hunger among the Indians. By the mid-1840s, many of the first people were taking seasonal jobs as farm laborers in order to learn Western-style agricultural methods and to earn income that could be traded for food

that was getting harder to find and gather by traditional methods. The dependence on the white settlers for sustenance, destruction of traditional ways of life and cultural institutions and depopulation caused by disease put intense pressure on indigenous bands as it became apparent that the traditional ways of *Illahee* were passing.

A measles epidemic among the Cayuse that struck in 1847 precipitated the events that came to be known as the Whitman Massacre and led to the first "Indian War" in the Oregon Country. Despair over the death of their children and anger at the Whitmans for their arrogant way of treating the natives led to a confrontation in which as many as sixty Cayuse and Umatilla fighters (and some whites) killed Marcus and Narcissa Whitman and ten other occupants of the mission. In addition, the Indians took as many as fifty hostages, many of them women and children.

The response to the violence at Waiilatpu was quick. Provisional governor George Abernathy authorized the raising of a volunteer force to protect the settlements, and a fifty-man company of volunteers known as the Oregon Rifles was raised and dispatched to Wascopam to defend the trading post there and keep Indians from moving on the Willamette Valley, where the majority of settlers lived. The hostages from Waiilatpu were soon ransomed by the HBC, but the Euro-American settlers were not satisfied. Early in 1848, Colonel Cornelius Gilliam led a force of five hundred volunteers to Walla Walla to punish the Cayuse and arrest the Whitmans' killers. In Washington, D.C., the massacre was used to justify further expansion into the area, and the Territory of Oregon was created in 1848.

The undisciplined volunteers were not notably successful in military operations against the Cayuse, and the war soon turned into a "scorched earth" campaign that saw the burning of Cayuse and Umatilla villages and the retreat of the Cayuse into the mountains. In 1850, five volunteers from the Cayuse—Tiloukaikt, Tomahas, Isiassheluckas, Clokomas and Kiamasumkin (known as the Cayuse Five)—surrendered to the Oregon volunteers and were taken to Oregon City for trial.

The first murder trial in Oregon history ensued as the Cayuse Five were tried by Judge Orville Pratt in front of an all-white jury that included Francis Pettygrove of Portland. The outcome of the trial was never in doubt, although the guilt of the Cayuse Five was. The five Cayuse argued that the death of Whitman was in accordance with Cayuse law, but testimony regarding Cayuse culture and values was barred from the trial. The Cayuse Five recognized their role as sacrificial victims, and they took their punishment, death by hanging, stoically.

The trial and execution of the Cayuse Five brought an official end to the Cayuse War but did not end the hostilities. Cayuse guerillas continued to fight against the white settlers until the tribe was defeated in the Yakama War of 1855. The execution of the Cayuse Five was the first, but not the last, unjust political use of the death penalty in Oregon.

# WAR BROKERS

*I am always in favor of any and all wars.*
*—General Joseph Lane*

The end of the Mexican-American War in 1848 left many Americans feeling as if war was a good way to solve political problems. The last half of the nineteenth century can be seen as the Golden Age of Warfare in North America. War and war threats were used both regionally and nationally in attempts to solve political differences or create political advantages for Americans. In Oregon, men like Joseph Lane and George Law Curry used war and threats of war to create Oregon as an ideological concept and a political identity. The Cayuse War helped pressure Congress into creating the Oregon Territory, and Lane, Curry and others saw the potential that war against Indians could have in building the political foundation for the state of Oregon.

The First Rogue River War, following the discovery of gold near Jacksonville, began after violent kidnappings and murders of Indians by encroaching miners angered the Indians into retaliating. The "war" fought by Oregon volunteers under the command of General Joseph Lane, the first territorial governor, was no more than a series of village massacres and retaliatory raids that forced the Indians to cede much of their land and left a great deal of hostility between Indians and Euro-American settlers in the Rogue and Umpqua Valleys of southern Oregon. Government reimbursement of war costs for the Cayuse War and the Rogue River War

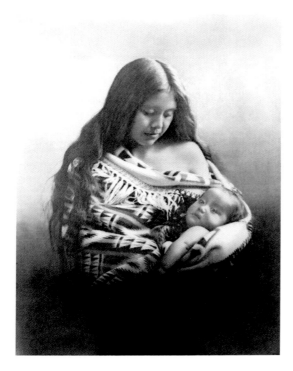

The relationship between Indians and white settlers in Oregon was complicated. Between brutal wars of extermination, the settlers tended to romanticize Native Americans. This photo—"Indian Madonna"—was very popular in the 1890s after the Indian population had been reduced to a tiny fragment of what it had been. Photo by Benjamin A. Gifford. *Courtesy of Old Oregon Photos.*

amounted to over $200,000, bringing much-needed capital into the cash-strapped territory. In addition, the volunteer officers, appointed by Lane, became politically powerful in their communities after the war, creating a class of small-town leadership politically loyal to the Democratic Party and personally loyal to General Lane.

The loyalty to Lane paid off right away as he was elected Territorial delegate to the U.S Congress. George Law Curry, who crossed the Oregon Trail in 1846, was appointed governor in Lane's place. Oregonians hailed Curry as the first Oregon pioneer to govern the territory. Curry saw his mission as creating the state of Oregon, and with the powerful lobbyist Joseph Lane in Washington, he saw Oregon enter the union at the end of his term as governor. The two men consciously used the threat (and the fact) of war to create the state. In order to do so, they had to create a war.

Men like Charles Drew and Bob Williams of Jacksonville were so vocal in their hatred of Indians and advocacy for war that they earned the facetious nickname "war brokers." Drew and Williams were little

more than tools for the real war brokers who held power in the state, but they were important tools in creating first the threat and then the fact of war. Drew, Williams and other Rogue River volunteers continued a low-intensity form of warfare against the natives of Southern Oregon. Militias with "colorful" names, such as the Exterminators, indiscriminately killed the natives of the Umpqua and Rogue River Valleys. By 1855, the Indians were forced to choose open warfare or piecemeal extermination, and the Second Rogue River War was on. The brutal conflict resulted in a great reduction of the Indians in southern Oregon, comparable to the diseases that had ravaged the Willamette Valley. The impoverished survivors were confined on reservations. The Jacksonville gold fields were already overcrowded, and the restless gold rushers were beginning to move north to Colville, Washington Territory by the time the Second Rogue River War began.

Washington Territory was carved out of Oregon in 1853, and its first governor, General Isaac Stevens, was attempting to create the state of Washington by negotiating treaties with the native people of the Puget Sound and Columbia Plateau. He used a combination of bluster, promises, bribes and threats to cow the native tribes into signing treaties that turned over their lands to the U.S. government and confined the natives to small reservations. The Walla Walla Conference of 1855, in which the Yakima (*sic*), Cayuse, Walla Walla and Nez Perce Treaties were signed, was a typical example of Stevens's style. Kamiakin, one of fourteen Yakama leaders, was recognized as "head chief of the Yakima [*sic*] Nation" by the 1855 treaty. Piupiu Maksmaks (Peo-peo-mox-mox), a wealthy horse trader who had long experience with white explorers and settlers, became "head chief of the Walla Walla." Both men had great influence among their people and family connections with many other bands, but neither ever achieved the level of authority and power that the United States assumed they had.

Stevens warned the delegates that time was short; news of the gold strike at Fort Colville was already spreading, and miners were crossing Yakama land in increasing numbers. If they didn't agree to the reservations, the United States would not be able to protect the natives from its people, Stevens warned. The Indians' objections were overridden by promises of schools and blacksmith facilities and the promise that fishing and hunting rights would continue in "traditional locations." Some chiefs were finally convinced by the annual salaries promised for "chiefs." When none of these ploys worked, Stevens resorted to direct threats. When Kamiakin refused

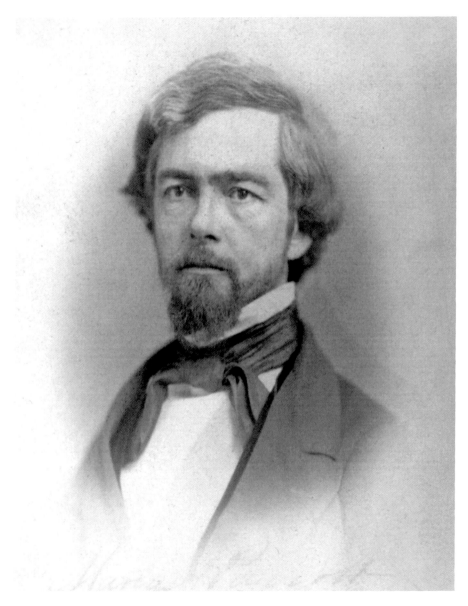

General Isaac Stevens, a veteran of the Mexican-American War and Washington Territory's first governor, negotiated treaties with many native tribes through a campaign of promises and threats. Photographer unknown. *Courtesy of U.S. Library of Congress.*

to sign and threatened to leave the conference, Stevens took him aside and promised that he would "be knee deep in blood" if he didn't sign. Witnesses reported that when Kamiakin finally "touched the pen" in the final ceremony, he was biting his lips so hard that they bled.

Kamiakin, son of a famous Palouse horse racer and a Yakama woman descended from Chief Wiyawiikt, had been a toddler when William Clark and two other members of the Corps of Discovery visited his home, Ahtanum, on the Yakima River in 1805. His family, his witty intelligence and his winning personality won great influence among the Yakama people and leadership of his band. In 1848, two Oblate (Catholic) missionaries, Eugene Casimir Chirouse and Charles Marie Pandosy, established the Mission of St. Joseph at Ahtanum. Pandosy, a twenty-three-year-old Frenchman, and Kamiakin became friends and mutual teachers. As Pandosy taught Christianity and Western science, Kamiakin taught his language and tribal lore, which Pandosy attempted to catalogue.

Kamiakin was a follower of the Dreamer Religion, based on the prophet dances of the early eighteenth century in which prophets told their dreams of the coming of the white men and the world falling apart. The Dreamers prophesied that the natives would rise once again and reclaim their land, but only after a long struggle. Kamiakin saw his duty to be part of that struggle, and he tried in vain to unite the natives of the Columbia Plateau to stop Euro-American encroachment once and for all. Open hostilities began just weeks after the treaties were signed at Walla Walla.

In 1855, the U.S. Army was spread very thin on the West Coast. General John E. Wool, who commanded the military Department of the Pacific from 1854 to 1857, reported that there were 1,600 soldiers in his department when he took command, but that number diminished "daily by desertions and discharge." When Major Granville Haller set out from Fort Dalles in September 1855 to punish the Yakama, he commanded 102 soldiers, all that were available in the area according to Wool. The bluecoats met a force of about three hundred Yakama and Klickitat warriors under the command of Kamiakin at Toppenish Creek. Although badly outnumbered, the arrogant U.S. Army dragoons picked a fight. During the fight, Kamiakin was reinforced by two hundred more Yakama warriors, and Haller was soon routed. Five American soldiers were killed and seventeen wounded, while the Indians suffered fewer casualties. In his report, Haller exaggerated the number of Indians he had faced, estimating two or three thousand.

Haller's defeat, and his exaggeration of Kamiakin's strength, sent panic through the infant city of Portland and other towns in the Willamette Valley and Puget Sound. Major Gabriel Raines, commander of Fort Vancouver, sent a letter to Governor Curry requesting reinforcement by four companies of volunteers. Curry, following his own agenda, called for eight companies of volunteers, later raised to ten, and refused to put them under federal command. Colonel James Nesmith kept independent command under Governor Curry. Public meetings in Portland resulted in a large recruitment. Most counties in the territory were expected to provide one company of volunteers (sixty men and five officers), but before the end of the war, Multnomah County would muster four companies. Prominent Portlanders such as Captain Alexander Ankeny; Lieutenant Hiram Wilbur, Portland's first town marshal; and seventeen-year-old Harvey W. Scott served with the Oregon Mounted Volunteers. General Wool ordered two companies of infantry, one of cavalry and an artillery regiment to Fort Vancouver, and the U.S. Ninth Infantry was dispatched to California for reinforcement, but the Federal troops would not arrive in their positions before 1856.

The volunteers mustered on the east side of the Willamette, opposite Portland, and marched to Fort Dalles. Major Raines, who was made a brevet colonel so that his rank would match Nesmith's, refused to arm any volunteers who would not muster into the U.S. Army, so Colonel Nesmith had to find arms for the volunteers himself. He had little trouble finding horses, but firearms were in short supply and artillery was nearly nonexistent; one company had a cannon and that was the entire artillery of the Oregon Volunteers. Major Raines mustered in two companies of volunteers from Washington Territory and marched toward Walla Walla. Colonel Nesmith and his seven hundred volunteers followed.

Kamiakin had retreated north, fearing that the soldiers would come into his country in large numbers after Haller's defeat. Yakama fighters harassed the pursuing troops but stayed out of their reach, and soon the pursuing army was frustrated. General Wool arrived at The Dalles and vetoed plans for a winter campaign against the Yakama. Blaming the volunteers for the lack of success, he ordered the federal troops back to Vancouver. Sensing the split between the Oregon troops and the Federals, Kamiakin began a political campaign to draw support from tribes all over the northwest. Most of the tribes in the region were unwilling to go to war against the whites.

Fort Walla Walla was a Hudson Bay Company (HBC) post near the present city of Walla Walla, Washington. At the outbreak of hostilities, settlers in the

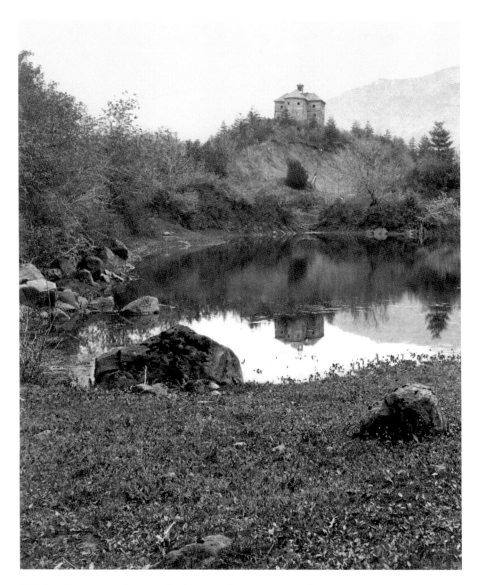

This blockhouse near Cascade Locks was built by Lieutenant Phil Sheridan after the 1856 raid by Klickitat and Yakama fighters. For decades, it protected the vital railroad that bypassed the rapids in the Columbia. Photo by Martin M. Hazeltine. *Courtesy of Old Oregon Photos.*

area had been warned to leave because of the danger of war. The HBC traders and many of the settlers retreated to The Dalles. Young men of the Walla Walla looted the abandoned fort and, by some reports, burned its walls. The Oregon Volunteers, ill-clad and poorly armed, suffered from exposure and frostbite at their camp near The Dalles, and they had a very difficult time receiving supplies. Late in November, Governor Curry arrived and took direct command of the volunteers.

Governor Curry was determined to have a wider war and knew that a winter campaign was the way to get it. He sent a force of about three hundred men under the command of Major Mark Chinn, including a company from Multnomah County to Walla Walla. Chinn pushed on past the looted HBC fort and built Fort Henrietta on the site of an Indian agency building that had been burned. Rations were so short that the volunteers were forced to raid Indian cattle and horses in order to eat.

On December 5, 1855, Piupiu Maksmaks and a small party, under a flag of truce, approached the camp of Lieutenant Colonel James K. Kelly, who had arrived to reinforce Chinn. Piupiu Maksmaks apologized for the looting of Fort Walla Walla and the burning of the Indian agency and offered restitution, saying that he wanted to have peace. Kelly had the chief and the entire party arrested. The Oregon Volunteers claimed that Piupiu Maksmaks was killed the next day when he tried to escape, but the injustice of killing a leader under a flag of truce and the subsequent mutilation and display of the chief's corpse united feeling against the whites. Most of the Walla Walla people fled to join Kamiakin, and even the peaceful Nez Perce and Cayuse were split, sending volunteers to join the Yakama fighters. The incident inflamed the war of words between Governors Curry and Stevens and General Wool, who accused the Volunteers of "brigand actions," attacking without "discriminating between friends and enemies" and "uniting all of the tribes of the region against us."

By February 1856, there were about two thousand federal troops, more than one-fifth of all U.S. troops at the time, in Oregon and Washington, and the Oregon Volunteers began to demobilize. Kamiakin, who proved to be a very able and inventive military leader, launched an attack against Seattle in January and part of the infant city was burned. In March, he launched a beautifully timed attack against the vital transportation hub at Cascade Locks, taking the settlement for a short time and destroying the important railroad link, first in the region, around the rapids. Kamiakin failed to capture and burn the two steamboats that served the Columbia, as he had planned, but he did create panic and fear in the Willamette Valley. Public

meetings were held, more volunteers raised and local Indians harassed and rounded up on new reservations.

The next spring, federal troops burned the mission of St. Joseph at Ahtanum and built two forts on Yakama land forcing the tribe to sue for peace. Kiamakin fled to his Palouse relatives and attempted to keep the resistance going. A tense ceasefire held until hostilities resumed in 1857. The second part of the Yakama war ended in 1858 with the destruction of several huge herds of horses, destroying the wealth of the Palouse people and leaving them impoverished.

# C.E.S. WOOD

## *A Rebel Formed by War*

*Can you stop the waters of the Columbia River from flowing on its course? Can you prevent the wind from blowing? Can you stop the rain from falling? Can you prevent the whites from coming? No.*
*—Governor Isaac Stevens*

Charles Erskine Scott Wood, an ex-army officer and graduate of West Point, settled in Portland to practice law and write in 1884. During the next forty years, Wood became the most powerful voice for the political underdog in the Pacific Northwest. Defending labor leaders and political radicals such as Margaret Sanger and Emma Goldman, Wood fought for civil rights for everyone. In addition to his law work, Wood was an important writer, considered the first "distinguished" poet of Oregon, and a talented painter. For most of his life, Wood spoke out against the maltreatment of Native Americans and racial discrimination in general. His political convictions were formed by his military service. He graduated from West Point in 1874 and was assigned to Fort Vancouver in 1876, where he became judge advocate for the post and aide to General O.O. Howard. Like many of the soldiers stationed at Vancouver, Wood loved the Pacific Northwest and settled in Portland after his resignation from the army.

In 1876, when Wood arrived in Vancouver, Portland was a gangly city that had grown to a population of over twenty thousand, but it was still fairly isolated from the surrounding countryside. East Portland was a sparsely populated area, and Albina (North Portland) had not yet

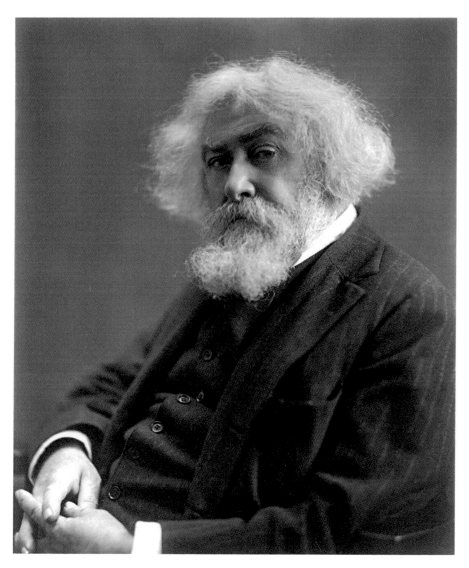

C.E.S. Wood settled in Portland in 1884, when he resigned his army commission at Fort Vancouver. Over the next forty years, he became one of the most well-known figures in Portland. He was Oregon's first "distinguished" poet and a lawyer who fought for civil rights for all people. Photographer unknown. *Courtesy of the Oregon State Archive.*

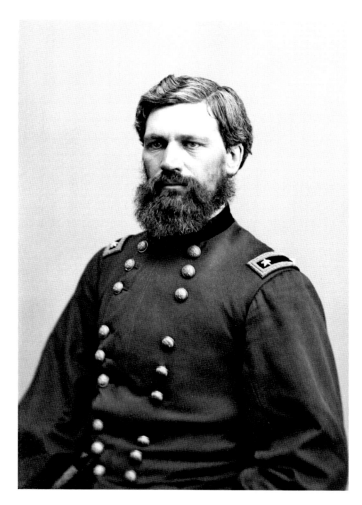

Fort Vancouver was a place of exile for army officers who had become political liabilities, such as General Oliver O. Howard, who commanded the fort during the Nez Perce War. Photographer unknown. *Courtesy of U.S. Library of Congress.*

been incorporated, leaving the Willamette Peninsula an undeveloped wilderness. Fort Vancouver was a remote outpost on the other side of the Columbia River. The fort was often a place for officers in disgrace to hide out so they could finish their careers quietly. Brigadier General Oliver O. Howard, who took command of the military District of the Columbia in 1874, had a distinguished career during the Civil War, winning the Congressional Medal of Honor, and losing his arm, at the Battle of Fair Oaks in 1862. His later career was marked by criticism of his hesitancy in battle and allegations of corruption as head of the postwar Freedman's Bureau. Howard came to the Pacific Northwest in

hopes of serving out the rest of his career in obscurity, but events in Eastern Oregon would not allow it.

Lieutenant C.E.S. Wood would prove to be a keen observer, an independent thinker and a thorough reporter. He also had a great respect for and interest in native people. While stationed in California, before coming to Fort Vancouver, he had lived for a time with a Paiute Indian family. Wood preferred a literary/artistic life, but family tradition had forced a military career on him. His father, Dr. William Maxwell Wood, had distinguished himself during the Mexican-American War and then served as surgeon general of the navy. Wood reluctantly accepted his military career, but he never bought into the racist/jingoistic politics that dominated the government during the Grant administration and set policy for the army. Historian Sherry L. Smith would later identify Wood as the "one officer [who] rejected the fundamental assumption of American civilization's superiority."

General Howard, known as the "Christian General," was an intellectual within the bounds of his fundamentalist beliefs and took young Lieutenant Wood under his wing, appointing him as judge advocate for the military department and corresponding with the young man frequently, helping him to develop his writing skills. The general gave Wood a room in his Portland home, and the young man spent much of his time in town, when he wasn't traveling. Lieutenant Wood was an unorthodox military officer, chafing under military discipline and taking advantage of his post to explore the area. As judge advocate, Lieutenant Wood traveled to all military posts in the region and often settled disputes between settlers and Indians. He was certainly aware of the trouble that had been brewing for years in the Wallowa Valley of eastern Oregon.

The Wallowa Valley had been a part of Nez Perce land for thousands of years, visited annually by a band led by the Joseph family for hunting and fishing. The salmon run on the Wallowa and the Imnaha Rivers supported not only the Wallowa band of Nez Perce, but bands of Umatilla and Palouse Indians as well. Since rescuing the starving Lewis and Clark party in 1805, the Nez Perce had been considered one of the friendliest Indian tribes in the region, usually allying with Euro-Americans in their wars against neighboring tribes. In return for their support against the Yakama and Palouse in the Yakima War, the Nez Perce had received a huge reservation that included the Wallowa Valley in Oregon, part of eastern Washington and most of the area that would later become the state of Idaho.

Trouble started for the Nez Perce the same way it had for the Yakama, with the discovery of gold on their land. The Clearwater gold rush began

in 1860, and the influx of miners into the area, as usual, created conflict with the natives. Following well-practiced tactics, the U.S. recognized Lawyer (Hal-al-hot-soot) as "head chief" of the Nez Perce and coerced him into signing a treaty that gave up 90 percent of the tribe's land, although he only had authority over his own band. Most of the Nez Perce, including the Wallowa band, refused to sign the 1863 treaty or to be bound by the agreement.

Chief Joseph (Hin-mah-too-yah-lat-kekt), the son of Old Joseph, who had refused to sign the 1863 treaty, continued to lead his band to the Wallowa Valley for the salmon run every year. Joseph was a follower of the Dreamer religion. Smohalla (Smoqula), who was born near Priest Rapids on the Columbia about 1815, began to preach his prophecy of a restoration of the native world in 1850, and some of his ideas had been very influential on Kamiakin during the Yakima War. After the war, he had wandered for several years before returning to preach about his further visions. Smohalla said that in order to put the world back into balance, the people must reject "civilization" and return to traditional ways of living. Joseph and his band had taken these ideas to heart and were attempting to continue their traditional way of life. Their big mistake was believing that the U.S. government was negotiating with them in good faith.

Early in 1877, Wood was sent as military escort for an exploration of southern Alaska. The expedition was aborted early, but Wood's interest in Alaska was not. He requested leave so he could explore and map the Yukon Valley, and while waiting for approval, he stayed with and studied a group of Tlingit Indians in the islands near Sitka. He received permission to explore the Yukon in June 1877, which would have been the first Euro-American expedition to the mineral rich region, but by the same ship he got word of the outbreak of war in the Wallowa Valley. Wood gave up plans to explore the Yukon and returned to Portland.

Things were tense on the Columbia as Lieutenant Wood and a party of other officers made their way to The Dalles. He didn't know it, but four weeks before his mentor had delivered the last straw at the Lapwai Council. General Howard had summoned the chiefs of several non-treaty tribes and laid down the law to them. Joseph, White Bird (Peo-peo-hix-hiix), Looking Glass (Allalimya Takanin), Husishusis Kute and Toohoolhoolzote were insulted by Howard's arrogant attitude. Toohoolhoolzote, a fiery speaker, was especially angry at Howard's high-handedness. Howard lost patience with Toohoolhoolzote's lecturing and threatened him, "If you do not mind me, if you say, 'no soldier will come to your place.' You will be tied up and

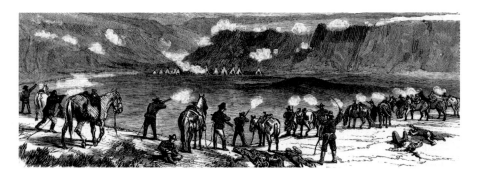

Lieutenant C.E.S. Wood kept an illustrated journal during the Nez Perce war. He "leaked" some of his drawings to *Harper's Magazine* in an effort to rehabilitate the image of his commander, General O.O. Howard. *Courtesy of the U.S. Library of Congress.*

General O.O. Howard came under intense criticism for his handling of the Nez Perce War. This was nothing new for Howard, who had been hounded for his conduct during the Civil War and with the Freedman's Bureau. *Courtesy of U.S. Library of Congress.*

your stock taken from you." Toohoolhoolzote replied, "I am chief. Who can tell me what to do in my country?" Howard had the chief jailed and seized his livestock. He told the other chiefs they had thirty days to relocate to the Lapwai reservation, and he ended the conference.

Joseph began gathering his people and herds for the long trek, over rough terrain and two rivers, from Wallowa to Lapwai. It would take a great deal of luck to make the 130 miles in thirty days. They had to leave much of their livestock behind because of their hurry, but the Wallowa band left with thousands of horses and cattle. Many Nez Perce were angry at the injustice of General Howard's order and the feeling that justice only existed for white people in America. Old grudges came to the surface, and there were several murders of white settlers by Nez Perce. Meeting other bands at Tolo Lake near the Snake River, the chiefs knew that the army would pursue them and take vengeance for the killings. They decided the best course was to move east and try to reach Crow land, but there was no guarantee they would be welcomed there.

On June 14, General Howard sent two troops of cavalry and a troop of infantry under Captain David Perry, a veteran of the Civil War and the Modoc War, to relieve the settlers in the Salmon River valley. As the force was leaving, General Howard took Captain Perry aside and told him, "You must not get whipped." "There is no danger of that, sir," Perry confidently replied. Meanwhile, Joseph and White Bird identified the young men in their bands who had killed settlers and hoped that turning them in would stop the army from coming. Looking Glass said he wanted to have nothing to do with it and led his people toward Lapwai. Joseph finally decided that turning in the killers would do no good; a fight would come anyway. He moved his people as quickly as he could to White Bird's settlement on the Salmon, where the position was highly defensible.

Overconfident, Captain Perry rushed his command over the rough terrain. They arrived near White Bird Canyon about 1:00 a.m., but Perry refused to let his exhausted men rest. He ordered them forward toward the entrance of the canyon. The Nez Perce used advanced tactics of concealment and ambush to take the U.S. soldiers by surprise and sharply honed mounted cavalry tactics to pursue the confused and routed federals. Thirty-four bluecoats were killed, about half of the force, and four wounded. The Nez Perce, about 150 fighters, suffered three wounded and captured more than sixty rifles and boxes of ammunition. It was a small scale Little Bighorn, and the victory troubled Chiefs Joseph and White Bird. They knew their only hope was to retreat across the Canadian border like Sitting Bull.

Lieutenant C.E.S. Wood arrived on June 27, just in time to take charge of the burial detail at White Bird Canyon. Burying the dead made the war real for the young officer, and he felt intense anger and hatred toward the Indians. Later in his life as a poet, Wood's journal would inform and inspire his verse. In an unpublished poem, *Ballad of the Burials*, Wood described the task in gruesome detail and memorialized "the field of dread and doom sown thick with what had once been men who spoke to us and were our friends." His revulsion at the grim reality of war and his disgust at the incompetence of the army at the battle of Cottonwood, which ensued a few days later, stayed with him the rest of his life. In the scrape at Cottonwood, Joseph managed to outmaneuver the awkward federal troops and leave them stranded for days on the wrong side of the river as he made his escape.

The Nez Perce and Palouse bands, now refugees, moved as quickly as they could to the east. The plan now was to cross the Rockies at the Lolo Pass and meet up with Sitting Bull's people in Canada. Lieutenant Wood operated as General Howard's aide-de-camp during the long pursuit that followed, mainly unsnarling logistical problems that plagued the force. In August, he escorted Chief Red Heart and a group of Nez Perce noncombatants to Fort Vancouver, where they were interred for the duration of the war. On the long trip to Vancouver, Wood got to know Chief Redheart and some of the other Nez Perce. It was on this trip that he lost some of the anger he felt after White Bird Canyon and began to see the enemy as human beings.

The Nez Perce retreat lasted through the summer and well into fall as the forces of General Howard pursued from the west and General Nelson Miles, in command of the new Yellowstone Military Department, pursued them from the east. Like Kamiakin, Chief Joseph and his allies won all the battles and lost the war. By autumn, the press was calling Howard "Day After Tomorrow" and Chief Joseph "The Red Napoleon." In October, General Miles's force caught the starving, exhausted Nez Perce near Bear Paw in Montana. Miles attacked and lost 20 percent of his command before settling down to a siege that lasted for four days before Joseph finally surrendered.

Lieutenant Wood wrote down the words that became famous as Chief Joseph's "I Will Fight No More Forever" speech. Wood has received a great deal of criticism for this speech by historians and others who doubt that the words belonged to the chief. It is probably true that Chief Joseph never delivered these words as a speech, since the Nez Perce believed it was undignified for chiefs to speak in public, but Wood and Joseph spent a great deal of time together after the surrender and became lifelong friends. Wood was a gifted poet, and he lent his eloquence in English to his friend,

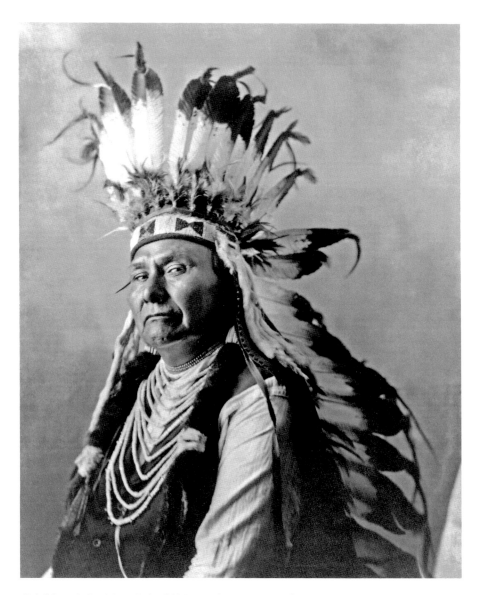

Chief Joseph lived in exile in Oklahoma for a decade before being allowed to settle on the Colville Reservation. He and C.E.S. Wood remained friends for the rest of the chief's life. He died in 1904, just four years after this photo was taken. Photo by DeLancey Gill. *Courtesy of Old Oregon Photos.*

but there is little doubt that the sentiment and the meaning belong to Chief Joseph.

Joseph and his people were exiled to Indian Territory in Oklahoma. Ten years later, they were allowed to settle on the Colville Reservation in eastern Washington, far from the Wallowa Valley that had been their home. In 1887, on his way to Colville, Chief Joseph visited his friend C.E.S. Wood in Portland. It was the beginning of Wood's career as a controversial public figure, and for the first time, he spoke about his differences with General Howard. For a decade, Wood had remained loyal to his old mentor, although he strongly disagreed with his conduct at the Lapwai Council and at other times during the war. He functioned secretly as an advocate for Howard with the press, leaking his drawings and dispatches to *Harper's Magazine*. These efforts were designed to build understanding and sympathy for the war and rehabilitate the badly tarnished reputation of the Christian General.

The friendship between Chief Joseph and C.E.S. Wood endured for the rest of the chief's life. Wood sent his son Erskine, as a teenager, to spend summers with the chief and learn about the Nez Perce way of living. The experience and the relationships that were built have lasted for generations. The twenty-first-century descendants of the two men still honor their ancestors by maintaining their relationship and participating in the annual Red Heart Ceremony of Reconciliation at Fort Vancouver.

# PART II

## *Woman's Work*

# WALKS FAR WOMAN AND OTHER FEMALE PIONEERS

*I think that in sparsely settled countries where help is scarce, women are more truly co-laborers with men, than anywhere else. And here I think they almost always find they can accomplish anything that they undertake.*
—*Ellen E. Sommerville*

Marie Dorion earned her Native American name Wihmunkewakan (Walks Far Woman) by making not one, but two harrowing treks across the wilderness of the Oregon Country. Both times she was accompanied by two young sons, and the first time she was pregnant, giving birth along the way to the first pioneer child born in Oregon. Born into the Iowa nation in 1786, Marie married a *metis* (French-Canadian/Sioux) trapper named Pierre Dorion Jr. and began a traveling career that would take her back and forth across the country several times. Pierre worked as a trapper and guide, and Marie accompanied him as they traveled throughout North and South Dakota, Minnesota, Iowa, Missouri and Arkansas. Although Pierre could be violently abusive toward his wife when he was drunk, the two made a good team and learned to speak several native languages.

In 1811, Pierre was hired by Wilson Price Hunt to act as guide for his overland expedition to reinforce the newly founded Fort Astoria at the mouth of the Columbia. Pierre insisted that his wife and two sons—Jean Baptiste, four, and Paul, two—accompany the expedition. Marie probably didn't know she was pregnant when the party set out from Missouri, but by the time they reached Fort Osage she knew and decided to stay with the

tribe of a distant relative to have her baby. Pierre, who at times showed great concern for his wife, shared the common attitude that she was his property, and he insisted that she continue the trip, physically putting her in a canoe to make her come along.

The expedition must have been especially hard on Marie as the only woman with sixty men. Among the Iowa, a matriarchal tribe, women usually spent most of their time with other women. Isolation and loneliness were common problems for pioneer women in the Oregon Country, and Marie had them both right from the start. Traveling while pregnant, with two toddlers and a husband who expected regular care, would have been arduous enough, but Marie served as a guide, diplomat/translator, nurse, food gatherer and cook for the entire expedition as well. Along the way, Marie demonstrated the resourcefulness and courage that would become the common denominator of Oregon's pioneer women.

At Fort Henry, near the headwaters of the Snake River, Wilson Price Hunt made a fatal error. Abandoning the party's horses and building fifteen dugout canoes, Hunt decided that they could make the one thousand miles to the Columbia River by rafting down the Snake. The Snake, a notoriously rough river, soon dashed their hopes, destroyed their canoes and killed one member of the party. On foot and with few supplies, the party broke into smaller groups, and the ones who accompanied Dorion and his family depended on Marie's skills for survival. Without a horse, she would have been carrying little Paul on her back most of the time, although she was nearly eight months pregnant by then. Marie gave birth to another son on December 30, 1811, during a snowstorm near North Powder, Oregon, but he died eight days later. The infant was not the only member of the expedition to die; of more than sixty who set out for Astoria, only forty-five made it, and it took more than a year for the last stragglers to finally arrive.

Many elements of Marie Dorion's story would become common to the pioneer women who followed her: isolation and loneliness, domination by her husband, extra work and death of children. Thirty years after Walks Far Woman blazed the trail to the Oregon Country, hundreds of her daughters followed on the Oregon Trail. Marie Dorion was in her twenties when she came to Oregon, but women of all ages crossed the country. For example, Abigail Scott was seventeen when she accompanied her family in 1852; Tabitha Moffat Brown, on the other hand, was sixty-five when she came into the Willamette Valley by way of the Applegate Trail in 1846. Both women's lives were changed by the journey. Scott, later Abigail Scott Duniway,

Pioneer women worked full-time farm jobs in addition to cooking, cleaning and taking care of the family. Feminists, such as Abigail Scott Duniway, equated women's work with slavery, referring to herself as a "pioneer drudge." Photographer unknown. *Courtesy of Old Oregon Photos.*

devoted the rest of her life to improving the lives of women. Tabitha Moffat Brown, touched by the plight of the orphans of the Oregon Trail, opened the first orphanage in Oregon and created Pacific University in doing so.

Most of the women who came over the Oregon Trail settled in rural areas on large farms where the nearest neighbor might be miles away. According to Abigail Scott Duniway, most of the women in Oregon at this time would go four months or more during the rainy season without seeing another woman. She would usually find herself cooking, sewing and cleaning for her own family, plus any hired hands who lived on the farm. Often single men who lived nearby would flock around a homestead with a woman to take advantage of home-cooked meals, sewing, laundry and other "women's work." Women would often do a full day's work of farm chores on top of their housekeeping, cooking and child care duties. Men worked hard, too, as life on an Oregon homestead required constant work, but they rarely had

responsibility for taking care of the children, and they could often count on being waited on hand and foot by the "little woman."

In small towns and rural communities, the career options for women were severely limited. Outside of being a homemaker, a woman could teach school or operate a millinery/dressmaking shop, although most communities could barely support one woman in either role. In Portland, there was slightly more opportunity, including professions such as doctor, lawyer and newspaper editor, but it took incredible persistence and fortitude for a woman to create a professional position for herself. Portland supported many dressmaking and millinery shops and had the additional options of laundress and boardinghouse keeper, although both ran the risk of the community assuming that the business was a front for prostitution. Prostitution was the other career option open to women in Portland, and it was a lucrative opportunity for many women of entrepreneurial nature. Prostitutes, however, often suffered even worse domination by men than wives did.

Women had little control over their own lives. Their property belonged to their husbands, and they were seen as property themselves. Husbands even had the legal right to bar their wives from testifying in court, which was greatly to their advantage in divorce cases. Husbands rarely faced punishment for physical abuse, unless the women in a community decided to take justice into their own hands, as they did in the case of Harry Roberts of Tampico, Washington Territory in November 1885. Roberts's treatment of his wife became so egregious that one night a dozen women came to his house, tied him to a fence and flogged him brutally. Such direct action was often looked on favorably by the community because under the law little could be done against wife beaters. In the Roberts case, the women involved were recognized by the wife of a Yakima merchant who sent each of the vigilante women a new dress pattern as her reward.

Most often, women who were abused by their husbands were helpless. If she testified and her husband was convicted, she was often reduced to poverty by the fine. If the husband wasn't convicted, the wife herself might be fined or even flogged for bringing "false charges." If the husband was jailed, she lost her sole means of support and might have to face even worse abuse when he was released. For example, in the case of John Gately of Portland in 1878, his wife's support was cut off when he was jailed for beating her. When he got out of jail, he stopped off long enough to get good and drunk before going home to chastise her. She was reduced to homelessness as he chased

Most of the women in early Oregon lived on remote farms and would go for months without seeing another woman. Isolation, loneliness and domestic violence were serious problems for pioneer women. Photo by Jesse A. Meiser. *Courtesy of Old Oregon Photos.*

her from their house, and she had to sleep in the woods. It was no wonder that some women decided to take the law into their own hands.

Mary Leonard, who later became the first woman to practice law in Oregon, was the most famous case of an abused woman using violence to defend herself against her husband. Leonard, a Swiss immigrant, who came to the United States as a child, settled in Portland around 1870. Being in her late twenties at the time, she was considered to be an "old maid" with little chance of finding a husband. Oregon was a good place for a woman to find a husband, though, with its ratio of three men to every woman; in 1875, she married Daniel Leonard, a ferryman and inn keeper from The Dalles who was twenty years her senior. The marriage was stormy from the start and soon became physically violent. By 1877, Mary had filed for divorce, a highly radical and risky solution to domestic problems in the nineteenth century.

In January 1878, Daniel Leonard was shot to death with a "small revolver." Mary was known to carry a single shot pistol for defense, and

she was soon arrested for murder. Her husband had filed a countersuit in the divorce case accusing her of adultery, and the co-respondent was indicted with her for the murder. Her "lover" was never found and might have been a figment of Daniel's drunken imagination. She spent nearly a year in jail before finally being acquitted by an all-male jury. At the time, conviction for murder meant a death sentence, and no court in Oregon had ever sentenced a woman to death. Although friends of Daniel's sat on the jury that acquitted his wife, they were all aware of his abusive behavior, and his reputation for violence probably influenced the verdict. Mary's trial inspired her interest in the law, and after keeping a boardinghouse in Portland for a short time, she moved to Seattle, where she was able to study law and become the first woman admitted to the bar in Washington Territory.

She was soon admitted to practice in Federal court in Oregon, but the Oregon Supreme Court ruled that the state constitution did not allow women to practice law. Mary Leonard lobbied tirelessly, with support from Abigail Scott Duniway and other Portland feminists, for a change in the law, and in 1885, she was successful. The next year, when the new law took effect, Leonard became the first woman admitted to practice law in Oregon. Although it is possible that gender prejudice saved her life during her murder trial, it seriously hampered her career. She was unable to secure clients, and most of her cases were for the defense in Police Court. She eked out a living for over thirty years, but her lack of formal education and sex discrimination relegated her to the margins of the law. She died penniless in her seventies in 1912.

It was not only women in bad marriages who broke gender barriers by doing jobs in the "men's sphere." By all accounts, the marriage of Minnie and Charles Hill was a happy one. It lasted more than sixty years, and for more than twenty of those years, they worked together on their steamboat, *Gov. Newell.* Born in Albany in 1863, Minnie was the daughter of Isaac Mossman, a Pony Express rider, and Nellie Jackson Mossman, who came on the Oregon Trail as a girl. Minnie married Captain Charles Hill at the age of seventeen and served an apprenticeship on the *Gov. Newell* before getting her federal riverboat license in 1882, the first woman west of the Mississippi to do so. Later, she attained an engineer's license as well. This feat was known as a "double header" and was a rare accomplishment, even for men. From 1882 until after the turn of the century, Minnie captained the *Gov. Newell*, with her husband as engineer, on its regular run between Lake Oswego and Astoria.

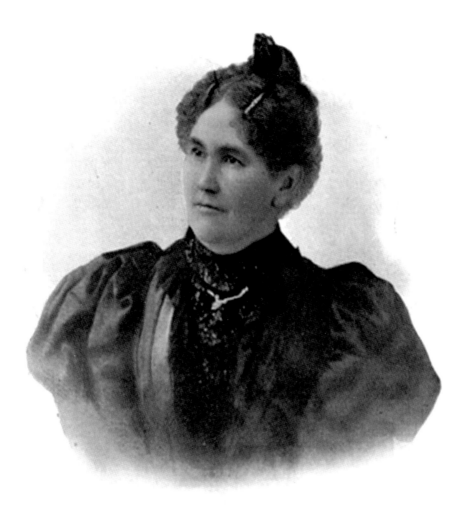

Dr. Bethenia Owens-Adair, Oregon's first female doctor, was a survivor of domestic violence. She was shunned by some women and harassed by men because she was divorced and a doctor. *Courtesy Offbeat Oregon History.*

Bethenia Owens, driven to despair by her husband's idleness and abuse, was divorced in 1859, a disgraceful thing for a woman at the time. With a young son to support, she worked at any job she could get: berry-picking, laundry, nursing, even teaching school, although she had no education of her own. After nearly ten years, she was able to save up $400 and build a home for herself and her son in Astoria. Having finally

outgrown the "young, ignorant, inexperienced child-mother" she had been, Owens turned to her own education in 1870. Having experienced the Oregon Trail, where one out of five travelers died before reaching their destination, and the incompetence of doctors who saw one in five children die before their fifth birthday in Oregon, Bethenia Owens was inspired to become a doctor.

It wasn't easy. She was embarrassed that she had to begin her education at the primary level, where her fellow students were more than twenty years her junior, but she progressed quickly. She graduated from the Eclectic School of Medicine in Philadelphia in 1874. The Eclectic School had a questionable reputation and taught a fringe medical technique known as hydropathy, but it was one of the very few medical schools in the country that would admit women. She returned to Oregon to face social ostracism from women and rude, offensive jokes and discriminatory treatment from men in Roseburg and Portland, where she practiced medicine until 1884. In that year, she married Colonel John Adair and moved to his farm outside of Astoria, where she continued practice as a country doctor until her death at eighty-six in 1926.

# DISORDERLY PRAYING IN STUMPTOWN

*We are rejoiced to see something started which will bring the women to the knowledge that they can deviate from long-established customs without bringing the heavens down upon their heads.*
*—Abigail Scott Duniway*

The Great Temperance Crusade of 1874 brought a great deal of excitement to Portland and created a crisis for the newborn Portland Police Bureau. Partly an expression of a national women's movement and partly the political expression of Portland's emerging middle class, the political movement, inspired by religious ministers, harnessed the energy and commitment of the city's women. Abigail Scott Duniway, who had been publishing the *New Northwest* for three years, was encouraged by the civil disobedience movement, but she saw its limitations immediately. "The first prayer that will be answered will be made with *ballots in your hands* to keep company with the prayer in your hearts," she said.

Alcohol was a powerful force in American culture. In 1830, the average American consumed eighty-eight bottles of whiskey per year, three times more than today. Many people started the day with an "eye opener" of hard liquor, and a lot of them continued to drink throughout the day. Whiskey, rum and beer were considered essential supplies for most workers. Alcoholism knew no race or class; in Portland in the 1870s, a prominent judge attained the nickname the "Whiskey Judge." Alcoholism fueled social problems such as domestic violence, poverty and child abuse.

Ministers, recognizing the link between alcoholism and social problems, began to preach temperance.

The temperance movement had been active in the United States for more than forty years when women in Ohio, especially those associated with the Methodist church, began a campaign of prayer and direct political action against saloons and "the liquor interest." Everywhere in the country, women were beginning to realize that their personal dissatisfaction was shared with thousands of other women. Ministers all over the country preached against "demon alcohol" and encouraged women to channel their feelings into temperance work. Local temperance leagues and unions sprang up in cities and towns across the country, especially in the west.

The movement began in Portland on March 10, 1874, when five ministers, including Reverend Thomas Lamb Eliot of the First Unitarian Church, preached sermons on temperance and the evils of alcohol. Eliot, like other preachers of the Social Gospel, believed that Christians had a moral duty to uplift society by taking action against social ills. Fifty ladies, including Helen Stitzel, were inspired by their ministers' words and began holding daily meetings in which women were encouraged to share stories of drunkenness in their families and the effects of alcoholism on their lives. This early form of consciousness-raising was a powerful tool for organizing, and the Woman's Temperance Prayer League (WPTL) was created on March 16. The WPTL was headquartered at the Taylor Street Methodist Church, and daily afternoon and evening meetings began. On March 18, the WPTL adopted an abstinence pledge and issued a public appeal for saloonkeepers to close their shops. By March 20, more than eleven thousand signatures had been collected on the Temperance Pledge. At the time, Portland was home to a few more than twenty thousand people.

As the momentum of the movement grew, the women of the WPTL began to look for ways to exercise their new power, and soon they decided to take their prayers to the source of the liquor evil. The meeting on March 23, at which the decision to begin direct action against saloons was made, created a split in the organization, and several members, opposed to civil disobedience, withdrew. The ones who stayed were strongly committed, and a campaign of praying and hymn singing in saloons began. Most saloonkeepers politely ignored the devout women, but Walter Moffett, owner of the Webfoot Saloon at First and Morrison and the Tom Thumb Saloon a few blocks away, took loud exception to the ladies' tactics.

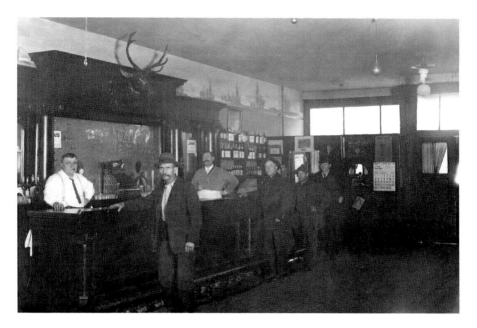

In the 1870s, Portland had a saloon for every forty men, women and children in town. Alcohol was vital to Portland's economy, and all of the great fortunes in town were at least partly based on the liquor trade. This photo was taken in 1915, shortly before Prohibition took effect. Photographer unknown. *Courtesy of Old Oregon Photos.*

Walter Moffett was a respected saloonkeeper known for running an honest joint (not a foregone conclusion in the wide-open town). In the 1870s, Portland had one saloon for every forty residents—man, woman and child. Historian Malcolm Clark Jr. was quick to point out that some of the children in town abstained. Drinking was not only a popular pastime; it was also a very profitable business. Most of Portland's wealthy and powerful men were involved in the liquor trade. William S. Ladd, the town's richest citizen and president of the first bank in the state, came to town in 1851 with a consignment of liquor and little else. Many wealthy businessmen, including John Caples, who would soon become district attorney, owned buildings that housed saloons and reaped large profits from them. Even James Lappeus, chief of the newly formed Portland Police Bureau, was part owner of the Oro Fino Theater and Gem Saloon, considered the fanciest drinking parlor in town. In addition, the city was dependent on liquor licenses for more than half of its revenue. The ladies of the WPTL were faced off against the city establishment and a powerful "old boys" network.

Moffett was a man with a bad temper and a dislike for "lady reformers." When two demonstrators came into his bar and began to pray and sing loudly, he ejected them forcibly. He also verbally abused them, calling them "whores" and saying they were not welcome in his place. After Moffett's abusive tirade, the WPTL began to focus on the Webfoot Saloon. Unwilling to force their way into the bar, the women protestors began to gather on the sidewalk across the street from the saloon in orderly groups, sometimes sitting on chairs supplied by sympathetic neighbors, singing hymns and praying.

Walter Moffett and his drunken clientele fought back with loud abuse, rude jokes, banging gongs, drums, firecrackers and even handguns. Moffett demanded that Police Chief Lappeus clear the streets because the noise was hurting his business. On April 7, Chief Lappeus arrested six protestors: Helen Stitzel, Mrs. Shindler, Mrs. Sparrow, Mrs. Ritter, Mrs. Fletcher and Mrs. Swafford. He arrested the women for "disorderly praying" and marched them toward the police station. The women insisted on being jailed, but Lappeus soon released them and threatened to have them physically ejected from the building. The next morning, they were back on the wooden sidewalk across from the Webfoot.

Over the next several days, the protests continued with growing numbers of protestors and even larger numbers of spectators. Moffett hired a group of small boys to bang gongs and drums in an effort to drown out the women's prayers. His drunken clients continued to harass the women, and their behavior got worse the longer the protests continued—and the more they drank. On April 16, tensions hit the breaking point. More than twenty protestors gathered in front of the Webfoot that morning, and soon there was a crowd of more than one thousand spectators. J.F. Good and a few other bystanders openly drank during the morning and hurled increasingly vile abuse at the women. Some of the bystanders in the crowd took offense at the drunken insults and defended the women protestors.

The sun came out in the afternoon, and tempers rose with the temperature. At one point, Helen Stitzel grabbed a Chinese gong out of the hands of a small boy who was harassing her. Walter Moffett, who stood in the door of his saloon glowering at the crowd, rushed to her and struggled for the gong. Stitzel got it away from him, and Moffett pulled a small handgun from under his vest and brandished it at her. As if Moffett's pistol was a signal, J.F. Good and others rushed forward and threatened the women with obscene curses.

# THE TEMPERANCE CRUSADE.
## FOUR HOURS IN A BAR ROOM.

**1ST HOUR
CYNICAL INDIFFERENCE.**

**2ND HOUR
MOCKERY AND DEFIANCE.**

**3RD HOUR
RAGE AND DESPAIR.**

**4TH HOUR
UNCONDITIONAL SURRENDER.**

It took more than fifty years for Portland drinkers to reach stage four, and it was never unconditional. In the 1870s, stages two and three dominated. Drawing by A.J. Fisher. *Courtesy of U.S. Library of Congress.*

William Grooms, former Portland city marshal, threw the first punch, hitting Good in the face. A general mêlée broke out at that point, and soon knives and guns were drawn. At least one man was hospitalized with stab wounds, and several were injured by thrown chairs, but no shots were fired. The Webfoot Saloon was trashed. The protestors of the WPTL stood by in stunned silence, afraid to even pray out loud in the face of the violence. Soon the police moved in and cleared the street. Stritzel and several others were arrested.

The six protestors were charged with disorderly conduct and received a one-day trial before an all-male jury. More than one jury member was involved in the liquor business, and some of them expressed clear bias against the defendants. Mrs. Ritter was proved to not have been present on the day of the riot, and charges against her were dropped. The other five defendants were convicted, and the jury asked for the court's mercy in sentencing. At the sentencing hearing the next day, Mrs. Sparrow, speaking for the defendants said, "We ask no mercy—we ask for justice." The judge sentenced the five women to five-dollar fines or a day in jail. The committed activists chose jail, but Chief Lappeus refused to hold them. Faced with open defiance from a group of respectable women married to property holders, the hard-nosed chief was at a loss.

The movement soon fizzled as it turned political; allying with the national Prohibition Party, the WPTL endorsed a slate of candidates in the next election. With its main support coming from women, who were not allowed to vote, the WPTL proved to be an ineffective electoral organization. Many of its members, politically conservative, rejected political activism and refused to participate in further efforts, either for temperance or suffrage. Abigail Scott Duniway became even more serious about her efforts to educate the women newly aroused by the political movement.

The split between "social feminists," who believed in the moral superiority of women and that the sex roles assigned by society were natural expressions of femininity, and "equality feminists," who believed in the equality of women and the artificiality of gender roles and were fighting for political, economic and social equality, developed during the Great Crusade and continued to plague the women's movement in Oregon. Abigail Scott Duniway railed against the temperance movement in her 1914 autobiography, *Pathbreaking*, claiming that the movement had delayed passage of the suffrage amendment in Oregon until 1912. She had a good point because the bill was introduced five times, starting in 1884, and was defeated each time except the last. Through the Oregon Equal

Suffrage Association (OESA), founded in 1871, Duniway worked for forty years to bring women the right to vote.

The temperance movement had a huge impact on the women of Portland. Some were radicalized, and for many of them, temperance would be a lifelong crusade. In the 1880s, the WPTL affiliated with the Woman's Christian Temperance Union (WCTU), and Francis Willard visited Portland to teach organizing skills to the members. "Home protection" through woman's suffrage would be a powerful call to conservative feminists.

# ABIGAIL SCOTT DUNIWAY

## *Remaking the World with Her Words*

*Poor baby! She'll be a woman some day! Poor baby! A woman's lot is so hard!*
—*Anne Roelofson Scott*

Abigail "Jenny" Scott was a young girl when she heard her mother say these words through her tears as she held her newborn daughter, Abigail's sister, in her arms. Abigail was already aware of the hard work involved in being a woman from watching her mother and helping raise her eight brothers and sisters. Life on the Illinois frontier was hard for everyone, but women, because of the gender roles strictly enforced by family and society, had to work twice as hard. In addition to extra work, women had little or no control over their lives or the lives of their children. When John Scott, Abigail's father, decided that the family should move to Oregon in 1852, he ignored his wife's protests and worries about her health.

Abigail Scott was seventeen when her family traveled west on the Oregon Trail. She was assigned to keep a journal of the trip, and she enjoyed the beautiful scenery and the freedom of life on the trail. Her clear voice comes through the words in her journal to describe the excitement, the boredom and the tragedy of the trip. A young man her age that she was sweet on drowned during a river crossing. In June, her mother died of "plains cholera" near Fort Laramie, and then in August, after finally reaching Oregon, her three-year-old brother, Willie, died. One of the most common elements of the experience of Oregon Trail emigrants was traumatic loss. By the time

the Scott family settled in the Yamhill Valley, Abigail Scott had experienced enough tragic loss to last her a lifetime.

Abigail taught school for a short time in the village of Eola. Lacking formal education herself but raised in a literate family, the young teacher had to study every night so that she could be ahead of her students in class the next day. Single young women of marriageable age were quite popular in Oregon in the 1850s, when the ratio of men to women was nearly twenty to one; Abigail married Ben Duniway in 1853 and gave up her teaching career to become a "pioneer drudge." Ben was an amiable man who enjoyed playing host to his single friends. In her 1914 autobiography, Abigail described her life as a farm wife, saying, "It was a hospitable neighborhood composed chiefly of bachelors, who…seemed especially fond of congregating at the… home of my good husband, who was never quite as much in his glory as when entertaining at his fireside, while I, if not washing, scrubbing, churning, or nursing the baby, was preparing meals in our lean-to kitchen."

Abigail Duniway had been writing poetry since her childhood and had enjoyed keeping the journal during the Oregon Trail trip. She described herself as a "scribbler," and she found time, amid all of her work, to put her thoughts on paper. In 1857 she sent a poem, *To a Burning Forest Tree*, to the *Oregon City Argus*. Editor W.L. Adams published the poem, credited to Jenny Glen, and praised her writing, suggesting that she should write a prose article. She began writing letters, signed "A Farmer's Wife," to the *Argus* and the *Oregon Farmer*. In 1859, she published her first novel, *Captain Gray's Company; or, Crossing the Plains and Living in Oregon*. The novel appeared in April, shortly after Oregon became a state. It was the first novel written and published in Oregon. Abigail was twenty-four years old.

Writing a novel was "a foolhardy thing for an illiterate and half bent farmer's wife to undertake," as she said in her autobiography. The novel was torn apart by critics, such as Asahel Bush and Reverend Thomas Hall Pearne, who objected to the book's romantic theme and poor grammar. Duniway was embarrassed and defensive about her first book for the rest of her life. She rewrote the story in 1905, now titled *From the West to the West: Across the Plains to Oregon*, and refused to reprint the earlier version. Good grammar or poor, Abigail Duniway had a strong, clear voice that comes through in her writing today as strongly as it did when it was written. Reading her work is like hearing a friend tell a story.

In 1859, Duniway had not developed her political consciousness and was not yet convinced of woman's equality. But she was in the process of raising her awareness. In 1860, she wrote a series of Farmer's Wife letters to the

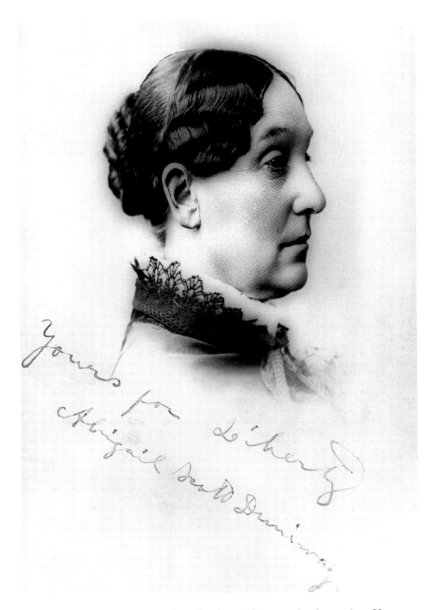

Abigail Scott Duniway was a talented writer and a committed organizer. Her newspaper, the *New Northwest*, allowed her to build a relationship with thousands of Oregonians. Before she was forty, she was known as Mother Duniway by men and women all over the region. *Courtesy of Library of Congress.*

*Oregon Farmer*, in which she pointed out the dangerous effects of drudgery and "excessive maternity" on the health of Oregon's women. She said she was "determined to agitate this matter until somebody goes to thinking." During the presidential campaign that year, when Edward Dickinson Baker campaigned in Lafayette for Abraham Lincoln, Duniway and six other women attended, accompanied by their husbands. The women were greeted by a hostile crowd of men and "audible hisses." Baker, who was a friend of the Duniway family from Illinois, welcomed the women, and Duniway later credited him with convincing her that equal rights for women was an important issue.

Finances were difficult for the Duniways, and in 1862, they lost their Yamhill farm and rented a home in Lafayette, where Ben worked as a teamster. That summer, Ben was disabled by a runaway team and was unable to do anything but light work for the rest of his life. With four children (she would have two more by 1869), Abigail became the sole support for her family. She went back to teaching and turned her home into a boarding school for girls. In 1866, she moved to Albany, where she taught in a private school and then opened a millinery and notions shop. Interacting with the women who patronized her shop helped her see that the frustrations and difficulties she faced were shared by all of her neighbors. It was during this time that she became convinced that women must have equal rights with men. Her husband told her that nothing would change until women had the right to vote and encouraged her dream of starting a newspaper.

In 1871, the Duniways moved to Portland, where Abigail's younger brother Harvey Scott was working as a junior editor at the *Oregonian*. With her teenage sons to run the printing press and her daughter to run a new millinery store, Abigail began publishing the *New Northwest* in May. The masthead of the first edition explained the goals and beliefs of the paper:

*A Journal for the people.*
*Devoted to the Interests of Humanity.*
*Independent in Politics and Religion.*
*Alive in all live issues, and Thoroughly*
*Radical in Opposing and Exposing the Wrongs*
*Of the Masses.*

The *New Northwest* soon became a welcome friendly voice in homes all over the northwest. Duniway wrote about her personal experience and political beliefs in a breezy, humorous style that was very accessible. Soon she began

receiving letters from her readers, many of which she printed and all of which she answered. A few women, such as Ellen Sommerville of Wasco County, became regular correspondents, reporting on the lives of women in remote areas of the state. Duniway spoke of her family life, health and her relationship with her husband as well as commenting on current events and politics. She often dispensed common sense advice on domestic issues, such as cooking techniques and which type of wash boiler worked best. She also gave frank advice to women about personal issues, such as her May 1871 "Answer to a Timid Woman." The timid woman wrote to the paper about her embarrassment if she were to pursue business and the men of her town were to talk about her. Duniway replied, "Tut tut! Suppose they do! They 'talk about' lazy women, idle women, expensive women, proud women, slatterns, wantons and prudes. They criticize everybody, and to set yourself down in silly inanity for fear they'll 'talk about you' won't prevent their talking about you, neither will your 'timidity' pay your bills."

When the paper came in the mail, it was as if a slightly subversive friend had arrived. Some husbands didn't like it, and when one reader complained that her husband intercepted the paper in the mail before she could see it, Duniway promised to send her subscription to the home of a friend. The paper was entertaining and useful. It helped Abigail Duniway create a relationship with the men and women of Oregon, and before she was forty years old, she was known by people all over the state as Mother Duniway.

In most editions of the paper, Duniway serialized novels that she wrote in order to illustrate her ideas about the situation of women. Each novel featured female protagonists and illustrated different aspects of women's lives. For example, *Edna and John, A Romance of Idaho Flat* (1876–77) dealt with the effects of unjust laws and religious bias. *Judge Dunson's Secret: An Oregon Story* (1883) told a harrowing tale of child abuse and double lives and showed that women must use techniques of domination and manipulation in order to gain their rights. *Blanche LeClerq, A Story of the Mountain Mines* (1886–87) examined the illusion of the "women's sphere." Duniway developed a strong style of writing, and her stories are very entertaining, which made their political message extremely accessible. In addition, her use of female protagonists gave her readers characters to identify with as they built an identity for themselves as Oregonians.

The written word was not the only weapon in Duniway's arsenal. After she acted as business agent for Susan B. Anthony's tour of the Pacific Northwest in 1871, she became a popular speaker. Traveling the region by steamer, railroad and stagecoach, she braved Indian attacks, primitive

HIDDEN HISTORY OF PORTLAND, OREGON

conditions and intense opposition with a positive attitude and an unfailing sense of humor. She organized suffrage groups in most of the towns she visited, and she constantly canvassed for subscriptions to her paper. She was often the target of male hecklers intent on refuting her points or "putting her in her place." With her quick wits and sharp tongue, she dispatched her detractors with ease, winning sympathy from her admirers and sending her hecklers off in humiliation. In Jacksonville, a mining town in Oregon's gold country and a haven for reactionary politics, she was met by protesters who pelted her with eggs and burned her in effigy. It was the only recorded time where she met physical opposition. Duniway took the protest in stride, saying, with her habitual editorial "we," "Only one egg hit us, and that was fresh and sweet, and it took us square on the scalp and saved a shampooing bill."

Duniway, who habitually signed her correspondence "Yours for Liberty," often made the connection between the treatment of women and slavery. Frederick Douglass was a hero of hers, and she often used his story as an example for the women's movement. She worked with "colored" women's groups. In 1872, Mrs. Beatty, one of the women who cast ballots in the presidential election, was black. In arguing with the election judge at the Morrison Precinct voting site, a debate that was extensively reported in the *Oregonian*, Duniway claimed that she had "worked off her previous state of servitude." She often lamented the fact that there was no Canada for fugitive wives to escape to. Although Duniway demonstrated racist attitudes at times, especially against Native Americans, she believed in the extension of civil rights without regard to race or religion or gender.

By force of personality and untiring work, Abigail Scott Duniway wrote and organized as a way to create the world she envisioned: one in which all men and women were equal and free. Her radical approach to politics and her position on alcohol prohibition—"prohibition is not liberty"—made her a controversial leader and involved her in several disputes. Her sharp tongue and sometimes abrasive personality did not help. In the 1890s, the women's movement split severely over prohibition, and Duniway resigned from some of the organizations she had helped to found.

Younger radicals, such as Dr. Marie Equi, championed Duniway's cause in the early twentieth century, and the women's movement in Portland became very contentious around the time women finally won the suffrage vote in 1912. The influx of young, energetic female activists into the movement was important to its success, but their embracing of the slightly discredited, radical Duniway led to open dispute. One of the things that the younger

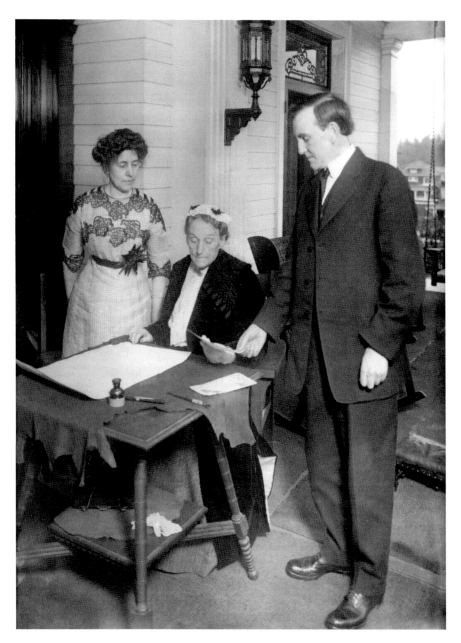

The crowning achievement of Abigail Scott Duniway's career was writing the Women's Suffrage Proclamation in 1912. Here she is signing the document with Governor Oswald West and Viola M. Coe, an act she compared to signing the Declaration of Independence. Photographer unknown. *Courtesy of U.S. Library of Congress.*

generation of feminists valued about Duniway was her direct action and civil disobedience.

Abigail Scott Duniway worked more than forty years as an editor, writer and activist. She ran the *New Northwest* until 1887 and followed with two other papers, the *Coming Century* (1891–92) and the *Pacific Empire* (1895–97). She organized for women's rights in Colorado, which got equal suffrage in 1893; Idaho in 1896; Washington in 1910; California in 1911; and Oregon in 1912. In 1912, Governor Oswald West honored her by asking her to draft the Women's Suffrage Proclamation after the amendment won the vote that year. She saw the drafting of the proclamation as the crowning achievement of her writing career and equated the act to signing the Declaration of Independence. She was the first woman to legally register to vote in Multnomah County in 1913 and legally cast her first vote in 1914. In failing health at the age of eighty-four, she died in 1915 and was honored as one of the founding mothers of Oregon.

# SUSAN B. ANTHONY

## *A Peaceful Warrior*

*It is a mistake to call Miss Anthony a reformer, or the movement in which she
is engaged as a reform; she is a revolutionist, aiming at nothing less than the
breaking up of the very foundations of society and the overthrow of every social
institution organized for the protection of the sanctity of the altar, the family circle
and the legitimacy of our offspring...*
—*Beriah Brown*

Susan B. Anthony surprised her audiences with her fluid, concise logic and
the common sense of her appeal for the equality of women. Before seeing
her in person, many expected a demon of radical politics who attacked the
very foundations of society. What they found was an intelligent, articulate
woman who was committed to her campaign to bring equality and justice
to all, men and women alike. She made three trips to Portland in her life
and was instrumental in training and inspiring more than one generation
of Portland's women to fight for the right to vote and for social equality. She
became a mentor to Abigail Scott Duniway during her 1871 visit to Portland,
but her later visits were in opposition to Duniway. The two women were
split by their beliefs about temperance and prohibition and by their ideas of
effective political tactics, but they shared common goals, and women could
not have secured their rights without the tireless work of both.

Anthony spent three months in the Pacific Northwest in 1871, travelling
extensively throughout Oregon and Washington Territory, with Duniway as
her constant companion and business agent. Duniway learned vital lessons

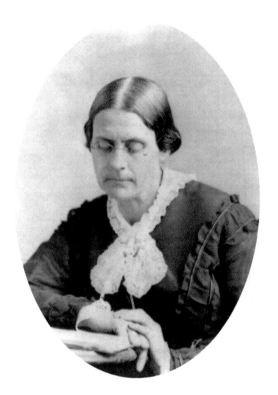

Like many women, Susan B. Anthony was radicalized by the temperance movement. Angry at the dominance of the movement by men and the suppression of women, Anthony dedicated the rest of her life to the fight for equal rights. Photographer unknown. *Courtesy of U.S. Library of Congress.*

in political organizing and public speaking from the woman who became her mentor, while Anthony was inspired and rejuvenated by the enthusiastic welcome she received from the women of the Pacific Northwest. The two women organized female suffrage groups in towns and cities all over the region, and Anthony became the first woman to address the Washington Territorial legislature. They also faced opposition, mostly from newspaper editors, such as Beriah Brown of the Seattle *Territorial Dispatch*. Some, like Brown, attacked her politics, while others ridiculed her appearance and her femininity. After the trip, Anthony returned to her national campaign on the East Coast, and Duniway continued the important work in the Pacific Northwest.

The defeat of the Oregon Woman Suffrage amendment in 1884 was the highpoint of the early suffrage movement in Oregon, but it left a damaged organization in its wake. The split between conservative and radical feminists became more pronounced, and Duniway's leadership came under fire. Duniway's open opposition to prohibition alienated

ANCIENT HISTORY

The press changed its perception of Susan B. Anthony over the years. By the time she died in 1906 she was a well respected political activist. After she died Anthony became a symbol of political resistance, as reflected in this *Life Magazine* cover from 1913. *Courtesy of U.S. Library of Congress.*

her from Oregon's conservative feminists; her opposition to public "rah rah" political campaigns alienated her from the radicals. Her insistence on western leadership for western organizations alienated her from the national movement, which was dominated by East Coast women. It was the low point of her career; she closed the *New Northwest* and even moved to Idaho for a time.

Duniway and Anthony differed on the alliance between women's suffrage and the temperance movement, but more importantly, they disagreed on the role of eastern organizers in the women's movement in the west. Anthony believed in centralized control and sent experienced organizers into Idaho in 1896 for the suffrage campaign. She advised Duniway to focus on the Oregon campaign and to stay out of Idaho. Duniway's independence, abrasive personality and sharp-tongued criticism contributed to the controversy of her leadership, and when Anthony visited Portland again in 1896, the two women argued about the dominance of eastern organizers in the campaigns in California and Idaho. After their meeting, Anthony dispatched Carrie Chapman Catt to Boise to lead the campaign in the territory. Duniway was hurt by the decision of her mentor, but personal difficulties, including the recent death of her daughter followed by the death of her husband, limited her activities. She and Anthony agreed to keep their differences quiet during the upcoming Women's Congress.

By the time Susan B. Anthony returned to Portland for the National American Woman Suffrage Association (NAWSA) convention in 1905, her health had taken a turn for the worse, and Oregon had become vital to the national movement. Her friend Elizabeth Cady Stanton had compared Anthony with Theodore Roosevelt, "the closest thing to a perpetual motion machine," but it wasn't close enough; the perpetual motion machine was slowing down. Anthony kept up a killing series of public speaking engagements and made two trips to Europe before retiring as president of the NAWSA in 1900. Even after her retirement, though, she continued her public speaking and provided leadership and mentoring for the new generation of feminists who were taking over leadership of the movement. Heart disease sapped her energy and made it more difficult to work and travel, but the importance of Oregon in national strategy made it imperative that she once again cross the country to the Rose City.

In the meantime, Portland had blossomed into a modern city. The Lewis and Clark Exposition, also in 1905, brought national attention as the country turned toward Oregon as a leader in democracy with the developing Oregon System of electoral reforms. The power of the Populist Party, under William

Alice Cooper's statue of Sacagawea, unveiled at the end of the 1905 NAWSA Convention in Portland, now stands in Washington Park. Sacagawea became a powerful symbol for women who were attempting to claim their political power by rediscovering women's history. Photographer unknown. *Courtesy of U.S. Library of Congress.*

S. U'ren, had transformed the government of the state, and its support of progressive Democrats had already paid off with Mayor Harry Lane in Portland and would soon see Oswald West as governor of the state. Woman's suffrage had failed twice in Oregon, but the recently adopted ballot initiative system offered a new opportunity in 1906. The NAWSA was committed to winning the vote for women in Oregon in 1906 and in California the following year. A key element in NAWSA strategy was to anoint a new leader in Portland, someone from the new generation—someone who was not Abigail Scott Duniway.

Duniway's insistence on "still hunt" campaign tactics, behind-the-scenes campaigns aimed at influential legislators and political leaders, had been discredited by the 1900 women's suffrage defeat. Anthony advocated an intense organizing campaign that would create grassroots organizations in the rural areas of the state. Signature gathering had been an organizing tactic for Anthony since the 1850s, and with the new ballot initiative, it would be a focus of the campaign. She also believed that experienced organizers from out of state should run the campaign in Oregon. Portland was chosen for the national convention of NAWSA in 1905 partly because of the attention Oregon was getting from the Lewis & Clark Exposition and partly because of the opportunity presented by the new electoral system. Duniway and Anthony kept their disagreements quiet during Anthony's visit, and the two women spent friendly time together and

shared the stage at important events such as Abigail Scott Duniway Day at the Exposition and the unveiling of the Sacagawea statue.

NAWSA, under the leadership of Anna Shaw, Susan B. Anthony's chosen successor, sent organizers to Oregon six months before the convention. Mary Chase and Gail Laughlin, experienced campaigners from New England, traveled throughout Oregon, organizing chapters of NAWSA in every county and most towns, identifying and training leaders and preparing for the initiative petition campaign that would follow the convention. The results of the 1906 vote, another defeat, would discredit Anthony's campaign model just as the 1900 vote had discredited Duniway's. It would, however, inspire a new generation of Oregon feminists. Women such as Sarah Evans, Dr. Esther Pohl and Emma Smith Devoe, of Tacoma, would gain important organizing experience and learn that the way to win was a combination of "still hunt" and public campaign tactics, using the resources of national organizations under local leadership. Conservative feminists, such as Lola Baldwin, were making their mark by crossing employment barriers into male dominated jobs. Others, like Dr. Marie Equi, freshly graduated from OSU's medical school, were still finding their path. Radicals like Equi must have been inspired by the words of Colonel C.E.S. Wood, who identified himself as an anarchist in his address to the NAWSA convention. He supported votes for women but warned them that voting changed nothing in a world that was increasingly dominated by corporations and their money.

The unveiling of the Sacagawea statue, the day after the NAWSA convention closed, was an important ceremony, and Sacagawea herself became an important symbol and inspiration for the new generation of feminists. Eva Emery Dye, a novelist who had popularized Sacagawea's role in the Corps of Discovery in her 1902 book *The Conquest: The True Story of Lewis and Clark*, and Sarah Evans, editor of the Woman's Work page of the *Oregon Journal* and tireless clubwoman/organizer, had conceived the statue and the unveiling as a woman-organized and -funded event. Alice Cooper, a Colorado sculptor, had been chosen to create the statue, the first dedicated to an Indian woman. Cooper used her art to turn the "little birdwoman" into a powerful symbol of women's leadership and struggle. Susan B. Anthony and Abigail Scott Duniway addressed the crowd at the unveiling, and both made explicit links between the life of Sacagawea, the first woman to vote in Oregon at Fort Clatsop in 1805, and the struggle for woman's suffrage.

The ceremony dedicating the statue was Susan B. Anthony's last public appearance in Portland. She continued to work, touring California and Kansas before going home to New York and meeting with President Theodore

Roosevelt shortly after, but her career and her life were winding down. She died in March 1906, reminding her followers on her deathbed, "Failure is impossible." After her death, Anthony became one of the most respected and recognized women leaders in the United States. Her inspiration was vital as the younger generation took control of the women's movement over the next decade, finally achieving the vote for women and mostly realizing too late that the warning of C.E.S. Wood—that the vote means little without economic equality—was accurate.

# PART III

*Tacit Agreements*

# TO BE TREATED AS
# FREE PEOPLE

*The negro is cast upon the world with no defense; his life, liberty, his property, his all are dependent on the caprice, the passion and the inveterate prejudices of not only the community at large but of every felon who may happen to cover an inhuman heart with a white face.*
—*W.H. Watkins*

Much has been written about Oregon's black exclusion laws and the thinking and legislative processes that went into their development. The majority of settlers who came to Oregon in the 1840s and 1850s were from the states of the Old Northwest (Ohio, Indiana, Illinois and Iowa) or the border states of Kentucky, Tennessee and Missouri. All of these states had experimented with laws to exclude or limit the rights of free blacks, and many of the immigrants were looking for an escape from questions of race. The first black exclusion law was passed in 1844, and it required African Americans who refused to leave the territory to be whipped with up to "thirty-nine stripes" every six months that they remained in Oregon. This law was never enforced and was repealed in 1845, but periodically throughout the territorial period, new anti-black legislation was passed until, in 1859, Oregon became the only state to be admitted to the union with black exclusion language in its constitution.

There were only two recorded attempts to enforce black exclusion in Oregon: Arthur Vanderpool, an African American saloon owner in Salem, was ejected from Oregon in 1851, and that same year, a complaint was

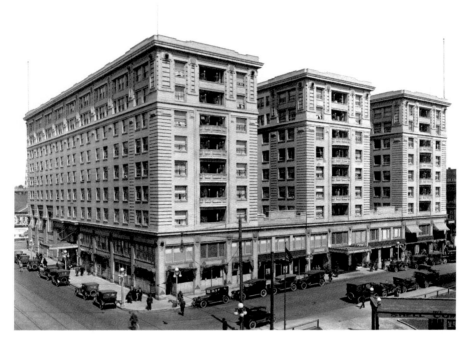

Hotels such as the Multnomah Hotel provided limited job opportunities for African Americans in Portland, creating a base for a black middle class. Portland was said to have the most highly educated porters, janitors and bellboys in the country. Photo by Columbia Studio. *Courtesy of Old Oregon Photos.*

made against Abner and Lynda Francis, popular merchants, for illegally living in Portland. We will look at the Francises' successful resistance to the law shortly, but their case points out the selective nature of these laws. They were used more as a threat than as a weapon. Enabling legislation was never passed for the constitutional language, although several attempts were made, but it remained as a threat. It became obsolete after the passage of the Thirteenth Amendment in 1866, but it wasn't repealed until 1926. Much racist language remained in the Oregon constitution until it was finally removed after a popular vote in 2000. For nearly 150 years, the words of the pioneers reminded Oregonians that the state was created as a haven for whites only.

Attempts to exclude African Americans from Oregon were no more effective than were attempts to exclude Asians or Latin Americans. Exclusion laws, like prohibition laws, are extremely vulnerable to resistance, both overt

and covert. Blacks came to Oregon in many roles during the early settlement period. Some worked as trappers and mountain men during the fur period of northwest history. Among these were George Washington Bush and Moses "Black" Harris. Bush, a veteran of the War of 1812, worked as a trapper and guide for the Hudson Bay Company before leading several wagon trains over the Oregon Trail. He settled near Tumwater, Washington, at Bush Prairie. Black Harris rescued more than one stranded party of emigrants, including the survivors from Stephen Meek's failed expedition, and became a legend along the Oregon Trail for his fancy clothes and his tall tales before his untimely death. Some came on ships, such as Allen Flowers, a cabin boy on the *Brother Jonathan* who jumped ship in Portland in 1865. He not only saved his own life, as the *Brother Jonathan* went down in a storm on its return to San Francisco, but he also fathered a large family of African American Portlanders.

Some came as slaves. Although slavery was never legal in Oregon, there were cases of slavery, and there are some interesting new studies on the subject. Lawsuits such as that over the Holmes children and the one brought by Lutesha Censor for back wages show that slavery existed in Oregon. It was more common for slaves to be freed, either before departure or on arrival in Oregon. In many cases, even slaves who were freed stayed with the families that had owned them. For example, Julius Caesar was freed by the family that owned him before they left Mississippi in 1850 to move to Albany, Oregon. Caesar, who went by his slave name George Taylor before changing his name to reflect his passion for oratory, stayed with the Taylor family as a farmhand until he was old enough to seek his fortune.

Some adventurous Exodusters (southern blacks who moved to the Midwest during Reconstruction) came as far west as Oregon. George Washington, the founder of Centralia, Washington, was one of them. He moved north of the Columbia to the unsettled area in Washington Territory because he disliked the Sundown Laws, which restricted the movement of African Americans after dark, and he wanted to find a place where he could be "treated like a free man." Being black, he was not allowed to file a claim on his land, but his white adopted parents filed the claim and sold it to George for one dollar. Many small towns in both Oregon and Washington had black settlers, and often they became important members of the community. Their numbers were small, and their stories were not always recorded. Isolated blacks in small communities were sometimes able to prosper, but Portland was the place where the real opportunity was.

Abner Francis came to Portland along with his wife, Lynda, in 1850 to go into business. The owner of successful clothing stores in Buffalo and Detroit,

Abner had been active in the anti-slave societies of both cities. Abner came to the West Coast for the California gold rush in 1849 when his business in Detroit failed. He came to California by ship, around the horn, and became a correspondent for Frederick Douglass's newspaper while he was there. After several trips between San Francisco and Portland, Francis settled in the northwest, working as a barber before opening his own store, which soon became famous for its fabrics. Abner was a man of strong political convictions, and he and his brother, O.B. Francis, attended the meetings that founded Portland and began self-government in the city. Being black men, neither of them was allowed to vote, but Abner spoke at the meetings, beginning a long tradition of African American orators in Portland. By the end of the 1850s, Abner Francis was a prosperous businessman worth more than $36,000.

When Abner and Lynda Francis's residency in Portland was challenged under the black exclusion law, they reacted like the political activists they were. The Francises went door to door collecting signatures on a petition calling for the repeal of the black exclusion law. They collected more than two hundred signatures, including that of H.W. Corbett, who would later be a U.S. senator, and Thomas Dryer, editor of the *Oregonian*. The law wasn't repealed until 1854, but the Francises stayed in Portland until they joined the exodus of West Coast African Americans to Victoria, B.C. in 1863. Francis, the irrepressible politician, became the first black man elected to the Victoria city council and died in that city in 1872.

By 1860, there were 128 African Americans living in Portland. Most of them found employment in restaurants or hotels or in domestic positions. Allen Flowers, fresh off his ship in 1865, found his first job as a busboy at the Lincoln Hotel. By 1867, Portland had a total population of about seven thousand, fewer than two hundred of whom were black, but the tiny African American community was politically active. That year, William Brown, a shoemaker originally from Maryland, brought suit against the city when his children were refused admittance to the public school. There was no law barring black children from public school, but there was organized resistance against integration. On more than one occasion, hostile crowds chased black children away from school. School board directors and city fathers Josiah Failing, W.S. Ladd and E.D. Shattuck proposed a tax refund for African American Portlanders so they could open their own school.

The Portland Colored School provided separate but equal education, for about twenty-five students, until the city voted to integrate the schools in 1870. The major reason for the vote was the cost of maintaining the

After the coming of the railroad in 1883, Portland's black community settled mostly in the area near where the Union Station would eventually be built, north and west from this intersection of Northwest Third and Couch. Photographer unknown. *Courtesy of Old Oregon Photos.*

separate school. Black pupils faced hazing, ostracism from white students and racist attitudes from teachers, and few of them went past the sixth grade in Portland Public Schools. The school district refused to hire black teachers until the 1940s. Black Portlanders who could afford it sent their children south or east for their education.

The small African American community in Portland attempted to win acceptance through their prosperity and orderliness. One tactic that they used to gain visibility and acceptance from the white community was to stage large celebrations for important events affecting African Americans. Beginning in 1865, Portland held annual Emancipation Celebrations organized and presented by the African American community. The celebrations included parades, street decorations, music and refreshments. Oratory was a major form of entertainment in the nineteenth century, and the Emancipation Celebrations always included plenty of speeches. George

Putnam Riley, a Boston native and Portland's first black real estate developer, became famous for his oratorical skills at these events. The Republican Party, always interested in cultivating the black vote, usually participated as well.

Not all of Portland's African Americans were orderly or prosperous. The Liva Saloon, a notorious North End dive, was known for racial mixing of blacks, mulattos, whites and Chinese. The Liva, like many Portland saloons, was a rough place where violence could erupt at any time. There were several "colored joints" for drinking, gambling and whoring in the North End. The Terminus Saloon, out of town on the Linnton Road, was famous for its beautiful African American prostitutes. Portland's black underworld in the nineteenth century was visible but very small, probably never numbering over a dozen or so individuals.

When the intercontinental railroad arrived in Portland in 1883, a large number of African American railroad employees moved to town. The stability of railroad jobs provided a good economic base for the black community, and the traveling porters became an important source of communication with African American communities around the country. After the railroad came to Portland, the city became the center of black community in the state, with usually about 90 percent of the state's blacks living there. In 1890, the Portland Hotel opened, and seventy-five African American men were recruited to come from North and South Carolina to serve the guests. The men of the Portland Hotel and their families became the foundation of a thriving African American community as they opened businesses to fill the needs of black Portlanders.

In 1899, Company B of the U.S. Army Twenty-fourth Infantry, a Buffalo soldier unit composed of African American soldiers with white officers, took up its post at Fort Vancouver. The Twenty-fourth Infantry had seen plenty of action in Cuba during the Spanish-American War, distinguishing themselves for bravery and discipline under fire. When they arrived in Vancouver, the unit was made up of about 60 percent new recruits and 40 percent combat veterans. While stationed at Vancouver, the men of the Twenty-fourth made regular contact with Portland's African American community, and some of them put down roots. Several NCOs, such as Edward Gibson and John Chase, retired while at Vancouver and settled in the area. Both men retired with more than thirty years of service and had attained the highest ranks available to blacks at the time, first sergeant and master sergeant. When the unit finally shipped out in 1900, some of the soldiers left wives or girlfriends in town, and many of the survivors of combat in the Philippines returned to the Rose City at the end of their service.

Between combat in Cuba and the Philippines, Company B of the Twenty-fourth Infantry was stationed at Fort Vancouver. They participated in the suppression of the striking Western Federation of Miners in Idaho in 1899 and made strong connections with Portland's black community. Photographer unknown. *Courtesy of U.S. Library of Congress.*

Duty was easy for the men of Company B at Vancouver. They worked routine garrison jobs at the fort, and most of them had the opportunity to attend school. Literacy was high among the Buffalo soldiers; in Company B of the Twenty-fourth, the literacy rate was nearly 97 percent. In addition to their garrison duties, the soldiers participated in parades and funerals in Vancouver and Portland. Company B led the annual Memorial Day Parade in Vancouver in 1899. But it was not all soft duty; in April 1899, the soldiers were deployed to Idaho to suppress striking miners in Coeur d'Alene and Kellogg. The Twenty-fourth Infantry, like most black units, was the first to be deployed into dangerous situations, and when rebellion broke out against the American occupation of the Philippine Islands in 1900, the Twenty-fourth was sent into action. The brutal guerrilla war that ensued lasted for

years and gave the U.S. Army its first experience in both jungle warfare and counterinsurgency—two missions that would be all too familiar in the twentieth century.

Fortunately, the black exclusion laws were not able to stop African Americans from settling in Oregon, but their migration was discouraged and slowed. In the 1880s, a decade when California gained nearly four thousand black residents, Oregon's black population was still under one thousand, with more than 70 percent of them living in Portland. By the first year of the twentieth century, Portland's black population had stabilized at about one thousand, representing 90 percent of the state's African Americans. That number doubled slowly over the next four decades. Tacit agreements with Portland's white citizens over the "place" of black people allowed for some individual opportunity. Black Portlanders could be prosperous as long as they accepted basic restrictions. For example, local skating rinks offered one night per week when African Americans could skate; public swimming facilities excluded blacks altogether. Restrooms and drinking fountains were never segregated, a fact that liberal whites liked to brag about, but few restaurants downtown would serve blacks, and most businesses would not hire them outside of menial positions. Portland soon developed the reputation of "the most racist city outside the South."

# GEORGE HARDIN

## *Police and the Color Line*

*You have to have funerals to solve some problems.*
—*Otto Rutherford*

Portland's small African American community was very active socially and politically from the start. In 1879, Allen Flowers, William H. Glasee, Henry Stone and several others formed the Portland Colored Immigrants Aid Society (PCIAS) to provide aid, assistance and encouragement for black refugees from the south. After President Rutherford B. Hayes withdrew the troops from the occupied south in exchange for electoral votes in 1876, life got worse for southern Negroes. The Ku Klux Klan was in its first burst of popularity, and lynchings were at an all-time high as the Invisible Empire attempted to replace slavery with a violently imposed subservience. A generation of African Americans, known as Exodusters, voted with their feet, moving north and west in search of a new life as the free people they were. Allen Flowers and his friends created an organization to recruit and assist Exodusters who wanted to try their luck in Portland. The PCIAS staged elaborate theatrical musical shows, featuring local musicians and oratorical readings, as an organizing tool and fundraiser. PCIAS entertainments were very popular, and the money raised went into disseminating information about Portland in the south, paying for railroad fairs, even providing short-term housing and employment assistance.

Black Portlanders with steady jobs, such as the Portland Hotel staff, saved their money in order to buy homes and start businesses, and a

vital African American community grew up near Union Station, which opened in 1896 after more than a decade of planning and construction. Housing was not segregated, and black families lived in neighborhoods on both the east and west sides of the Willamette, but many of them worked for the railroad and spent their days at the railway station where they earned tips. Black-owned businesses, such as the Rutherford Brothers' Haberdashery and Barbershop at Northwest Broadway and Flanders, catered to the prosperous community, while providing social space for that community to grow. "White Trade Only" signs were considered to be grave insults and often became the focus of protest. Portland blacks knew where they were not wanted and stayed away; they didn't need signs to tell them. Southwest Sixth Avenue became notorious for the "color line" its businesses enforced.

Many of the businesses downtown, other than restaurants, were happy to accept black patrons but would never consider hiring them outside of menial positions. Fair employment became an important civil rights issue as the African American community began to feel its power. The passage of the Fifteenth Amendment in 1870, giving African American men the vote, brought on a great celebration among Portland's black community. Ben Stark, the Democrat railroad and real estate tycoon, was the first politician to court the black vote, but it soon became a habit among Portland's Republicans. By the 1890s, Joseph Simon, relying on the talents of Jonathan Bourne and Larry Sullivan, had created a well-oiled political machine within the Republican Party. Simon recognized orators such as Julius Caesar, who enthusiastically spoke in favor of Benjamin Harrison and William McKinley, and actively courted support from black voters.

In 1892, the New Port Republican Club (NPRC) was formed, mostly by Portland Hotel employees, in order to support the reelection of President Benjamin Harrison. At its founding meeting in August 1892, the club endorsed a slate of candidates that it recommended for public employment. Moody E. Scott was nominated for a position in the city recorder's office; George Hardin for policeman; Henry Taylor for detective; and Joe E. Banks for mail carrier. In September 1892, Moody Scott, who held a teaching certificate and had a degree from a southern seminary, was hired by the county auditor's office as a typist clerk, becoming the first female African American public employee in Portland. The other candidates would have to wait.

George Hardin, who came to Portland from Illinois in 1891, worked as a bartender and hotel clerk, but his heart was set on police work. The

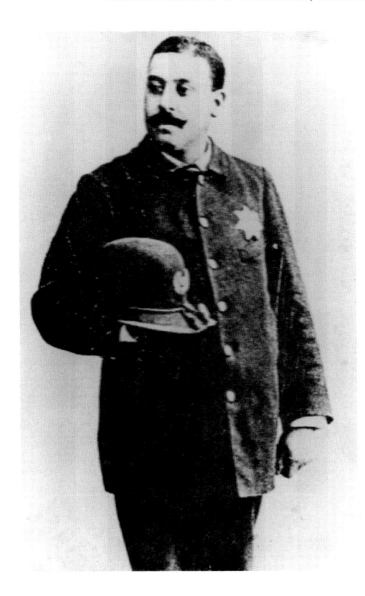

George Hardin, Portland's first African American police officer, has been presented as a symbol of the racial integration of the Portland Police Bureau. The truth is that he worked for the PPB for only a short time and then spent twenty years trying to be rehired before finally becoming Multnomah County's first black sheriff's deputy in 1915. Photographer unknown. *Courtesy of Portland Police Historical Society.*

NPRC, with support from the PCIAS and the Independent Colored Men's Organization (ICMO), kept up the pressure. The Republicans were better at making promises than delivering on them, but in 1894 during a shakeup of the department, two "colored patrol drivers" were hired: George Hardin and John Harry Hooper. The Depression of 1893 hit Portland hard, and city finances were scarce and layoffs frequent. Harry Hooper lost his job

after two months and a spectacular runaway patrol wagon accident; nine other officers were laid off at the same time. In July 1895, eleven more officers—including George Hardin, who was working as a patrolman on the eastside—were laid off as the Portland Police Bureau (PPB) was cut to the bone.

Hardin went back to his old profession of bartender, sometimes also working as a porter or hotel clerk, but he never gave up on his dream to become a police officer. He continued to apply for jobs when they were available, but other than M.M. Stephenson, who was a night shift patrolman for one week in 1896, the Portland Police Bureau never hired another black officer until World War II. The growing support the Populist Party was gaining in the state and its alliance with the Democratic Party in 1896 pushed the Republicans out of power in the city. African American political influence declined significantly over the next few years, and Hardin had to wait until 1915 before he was hired as Multnomah County's first black deputy sheriff.

Between George Hardin's stint with the PPB and his becoming a deputy, the African American community in Portland continued to grow in prosperity and stability. In 1896, A.D. Griffin, the first black Oregonian to attend a Republican convention, started publishing the *New Age*. A conservative publication, the *New Age* attempted to educate white audiences on the sober, industrious honesty of Portland's black citizens. Public employment for African Americans came very slowly. In 1900, M.W. Lewis was hired as a census enumerator; Arthur A. Turner became Portland's first black mail carrier in 1909; and in 1919, Ralph Flowers was hired as a mechanic in the city garage. Flowers, grandson of Allen Flowers, was supervising the garage when he retired in 1952. He also became the first black service station operator in Portland and the first black auto dealer.

In 1906, the Golden West Hotel opened at Northwest Everett and Broadway, just blocks from Union Station. The Golden West provided an important community space with Waldo Bogle's barbershop, A.G. Green's ice cream parlor and George Moore's Golden West Athletic Club and Turkish bath. In addition, the hotel featured a Chinese restaurant that became a popular gathering place for black families attending church in the neighborhood. Portlanders who lived in the city between 1906 and 1931 remembered the Golden West as the geographic center of the black community. The hotel provided vitally needed accommodations for black travelers, and many famous entertainers,

sports figures and civic leaders such as Illinois congressman Oscar DePriest and union organizer A. Phillip Randolph stayed at the Golden West when they visited Portland.

After twenty years of trying, George Hardin was finally sworn in as a Multnomah County sheriff's deputy in 1915. Hardin lost his wife around the time he was hired by the county, and he poured his grief into his police work. In 1916, prohibition became law in Oregon, and the county sheriff took on major responsibility for enforcement of the new law in Portland. Hardin was involved in several arrests of railroad porters at the Golden West Hotel for drinking. The word soon spread throughout the rail yard: Portland was a dry town. He remarried in 1921, and his second wife, Ruby Maddox, remembered her husband's experience for the *Oregonian*'s Steve Erickson in 1975. "He certainly didn't have any trouble in the sheriff's office," she said. "He was thought just as much of as any of the other deputies. They [white deputies] used to come by here to visit him all the time." Hardin soon had a good reputation among his fellow deputies. He joined the jail unit in 1926, when the Multnomah County jail was expanded to house more than four hundred prisoners. He stayed on staff at the jail until his death in 1938.

The Police Bureau remained a white organization until the 1940s, when growing numbers of African Americans in Portland, increased racial tensions and labor shortages opened employment opportunities for minorities and women. The Multnomah County sheriff's department took the lead in hiring black officers as the department had responsibility to enforce laws in Vanport. Deputies Matt Dishman and Bill Travis became leaders in Portland's African American community. The PPB hired a few black officers as part of the Veterans Patrol during the war, but they were part-time "special" officers who functioned mainly as air raid wardens and were not official members of the police force. It wasn't until 1946 that U.S. Army Air Force lieutenant Charles Duke scored first place in the civil service exams and was hired as an officer. Duke had been a member of the famous Tuskegee Airmen fighter squadron and had seen serious action in Europe during the war. Not many people know that twelve members of the famed African American fighter squadron were from Oregon.

Police Chief Leon V. Jenkins lamented that another Negro had not passed the exam so he could partner with Duke. Many white officers refused to work with him, but he stuck it out for five years. His two brothers, Horace and George Duke, were hired shortly after Charles,

Lieutenant Charles Duke (middle), a World War II fighter pilot with the Tuskegee Airmen, was hired by the Portland Police Bureau in 1946. He only stayed on the force a few years, but his brothers, Horace and George, stayed with the department for more than twenty years, often acting as partners because white officers refused to work with them. Photographer unknown. *Courtesy of Portland Police Museum.*

and both of the younger men, also military veterans, made careers with the police bureau. The brothers usually had to partner together because white officers refused to work with them, but both men had distinguished careers as police officers. George remained with the bureau into the 1960s, and Horace retired in 1982. Integration of the Portland Police Bureau was a slow and tedious process that never achieved major results until the 1970s. The situation for black female officers was even worse; the first black woman hired as a police officer in Portland was Carmen Sylvester in 1974.

# BEATRICE MORROW CANNADY

## Tea and Racial Equality

*Segregation is the root of all evils, for when people do not know one another they are suspicious and distrustful of one another. Only by contact of the races will… an understanding be reached.*
*—Beatrice Morrow Cannady*

The twentieth century saw an increase in racial discrimination against African Americans in Portland. "White Trade Only" signs, which had been rare in the nineteenth century, were seen more and more. Discrimination in public accommodations, such as theaters, restaurants and amusement parks, was common and socially accepted. In 1905, McCants Stewart, Oregon's first African American attorney, brought suit for discrimination against the Star Theater in the name of Oliver Taylor, a Pullman car conductor. Taylor and some friends had bought tickets for the show at the Star Theater and then were informed by an usher that they could only be seated in the balcony, a location commonly referred to as "nigger heaven." Taylor, insulted, insisted that he and his friends should be seated in the main auditorium, and when the usher refused, Taylor's party left the theater.

Attorney Stewart demanded $5,000 in damages for the humiliation, an amount equivalent to over $120,000 today. Judge Frazier ruled that a theater ticket is a revocable license, and the theater was only responsible to refund the price of the ticket. The judge pointed out that his ruling would apply whether the plaintiff were black or white, so it was a racially neutral ruling. The Oregon Supreme Court eventually awarded a small amount

Beatrice Morrow Cannady believed that the more white people learned about African Americans and their contributions to American culture, the better relations between the races would be. As part of her education program, she invited culturally important African Americans, such as Langston Hughes, to visit Portland. Photograph by Gordon Parks. *Courtesy of U.S. Library of Congress.*

for damages to Taylor, but segregation in public facilities, if not legally recognized, was at least considered legitimate. Stewart, disillusioned with Portland and depressed over the small extent of his legal practice, left for California shortly after the Taylor case.

In 1903, McCants Stewart had been involved with founding Portland's second African- American newspaper, the *Advocate*, along with Edward Cannady, Edward Rutherford and several other "Portland Hotel men." The *Advocate* provided news of concern to African Americans, reporting on lynching, racial discrimination and the achievements of African American communities around the country. In addition, the *Advocate* took a positive approach to local race relations and reported the achievements and developments of Portland's African American community. Through its editorial page, the *Advocate* provided a citywide forum for debate on issues important to the black community.

Nine men were involved with starting the newspaper, but many of them dropped out of the project after a couple months. The work was demanding, and most of the men were already working two jobs, so the attrition rate on the staff was high; others, like McCants Stewart, left town altogether after a few years. By 1912, Edward Cannady was publisher/editor and was running the paper pretty much single-handedly. Cannady, originally from St. Louis, Missouri, came to Portland around 1901 and ran the hatcheck concession at the Portland Hotel. He worked long hours at the hotel and gained a national reputation as a man with "a great memory for heads." Cannady cared for the hats of Portland's most prominent visitors, including Presidents Theodore Roosevelt, William Howard Taft and Woodrow Wilson. In addition to working long six-day weeks, he made sure that the *Advocate* came out every Friday.

In 1910, thirty-year-old Edward Cannady began to correspond with an eighteen-year-old college student in Texas named Beatrice Morrow. Morrow's grandfather, Jackson Morrow, founded the west Texas town of Littig after being freed from slavery. The Morrows were raised to value education, and Beatrice and her eleven brothers and sisters were all college educated. Beatrice studied domestic science and art and received a teacher's certificate. She was a talented musician and aspired to be an opera singer, which she studied at the University of Chicago. In 1912, Beatrice bought a train ticket to remote Portland to meet the man who worked at the fancy hotel and ran a weekly newspaper. There is little information on how Beatrice Morrow made her decision, but maybe she fell in love with the man, the city or the opportunity to run a newspaper.

Whatever it was, twenty-year-old Beatrice cashed in her return ticket and married Edward Cannady.

Black women had been politically active in Portland since the time of Lynda Francis and the first days of Portland as a city. In 1872, Mrs. George Beatty had joined Abigail Scott Duniway at the Morrison Street Polling place and insisted on voting in the presidential election. Beatrice Morrow Cannady jumped into political activism with both feet. She took over operation of the newspaper and became its main reporter. In 1914, she became the founding vice-president of the Portland chapter of the National Association for the Advancement of Colored People (NAACP). Cannady was trained as a teacher, and her main tactic to improve race relations was education. She became a regular speaker at both of the new schools in town, Lincoln High School and Reed College. She believed that if black people and white people had the opportunity to get to know each other, stereotypes would wear away and race relations would improve. There is no record of Cannady meeting Abigail Scott Duniway, although it is possible that they met, but she used a similar style of journalism to reach and educate her readers. Cannady's personality soon came to dominate the newspaper, and over the next two decades, her voice became the voice of Portland's African American community, or at least a significant part of it.

Beatrice Morrow arrived in Portland near the end of one of the most politically progressive times in the city's history. The Oregon System, which included the ballot initiative, referendum, recall election, primary elections and popular election of senators, had been developed by William U'ren and his alliance of Populists and Democrats over the previous decade. In 1912, women got the vote, and the political reaction began to set in. Prohibition was passed in 1913, taking effect in 1916. Also in 1913 Oregon passed its first eugenics law, mandating sterilization for homosexuals, the mentally retarded and other "undesirables." In 1915, D.W. Griffith's film *Birth of a Nation* came to Portland. The film was a lurid tale of the Civil War and Reconstruction that included a graphic scene of the Lincoln assassination. The film legitimizes racist ideas about black people and glorifies the Ku Klux Klan as the "savior of the white race." Nationally, the film sparked a revival of the KKK, and in 1921, organizers for the group came to Oregon and began to organize chapters.

Beatrice Morrow Cannady led the protest against *Birth of a Nation* when it was scheduled for showing at the Heilig Theater in August 1915. She wrote scathing articles about the film's historical inaccuracies and the inflammatory nature of its portrayal of both African Americans and the KKK. Although

D.W. Griffith's film *Birth of a Nation* (1914) spurred a national resurgence of the Ku Klux Klan. By 1923, the KKK had as many as twenty thousand members in Oregon, and it exercised significant political power until its elected candidates were implicated in a corrupt construction deal involving the new Burnside Bridge. Photographer unknown. *Courtesy of U.S. Library of Congress.*

her protest caused intense debate in Portland, it did not convince the newly formed Board of Motion Picture Censors (BMPC) to stop the showings. When she appealed the board's decision to the mayor and the city council, both were reluctant to overturn the censor board's ruling. The film ran for more than a week to sell-out crowds. Cannady remained firm in her opposition to the film, and she continued to protest its showing in town in 1918 and 1922. In 1931, when the film was released in a sound version, Cannady, with the help of the national NAACP, got the BMPC to stop it from being shown in Portland. By the end of the year, the board overruled itself, and the film was scheduled for an engagement at the Heilig Theater. Cannady personally appealed to Floyd Maxwell, the theater's owner, and

asked him to reconsider showing the film. Maxwell relented, withdrew his application to show the picture and gave Beatrice Cannady her first victory on the issue.

Cannady was right to oppose the showing of the film. Although technically brilliant and innovative, incorporating many new cinematic techniques and devices, the film's hateful politics and emotional manipulation made it dangerous. After the film's opening in Atlanta, the Ku Klux Klan, a guerrilla organization that had been formed to force black Southerners into subservience during the Reconstruction period, was revived as a "fraternal" organization. The KKK gained national prominence, attracting support in northern and western cities where it had no historical basis. By the 1920s, the resurrected Klan was a political power at the local and state levels in several communities, including Portland.

Beatrice Cannady's political protests were important because they became a rallying point in the black community and a strong organizing tool, but her most effective work was as "goodwill ambassador between the races." She kept up a demanding schedule of speaking engagements, especially in the high schools, and hosted interracial teas at her home that promoted racial understanding and acceptance. Her teas were one of her most radical and effective inventions. The teas usually included musical entertainment and speakers designed to demonstrate the cultural achievements of African Americans. She invited racially mixed groups to enjoy entertainment and refreshment in her home and encouraged intermingling and "getting to know one another." Believing that anyone could sit in a public place with anyone else, she felt that getting people to cross racial barriers was an important part of the process. Using her home as a welcoming, cultured environment, she encouraged white people to overcome prejudice and come in. Many whites were afraid to enter the homes of black people because of racial stereotypes and beliefs and were pleasantly surprised by the comfortable and intellectually stimulating environment that Cannady created. Soon her teas were being attended by racially mixed crowds of one hundred to two hundred, and several other Portlanders, both white and black, began to hold interracial parties and teas in their homes.

While Beatrice Cannady worked tirelessly to improve race relations by promoting mutual understanding and respect, racism was increasing in Portland. In 1919, the Portland Board of Realtors (PBR) included a clause in its code of ethics barring realtors from selling property in a neighborhood to anyone who would bring down property values in that neighborhood. This effectively began official segregation of housing in Portland, and tacit

Seating for blacks was only allowed in the balcony of the luxurious Oriental Theater on SE Grand Avenue. In 1928 Beatrice Morrow Cannady insisted on being seated in the main auditorium with her sons, but the humiliation of securing a seat ruined the show. Photo by Lyle E. Winkle. *Courtesy of U.S. Library of Congress.*

agreements among realtors, landlords and other members of Portland's establishment limited African Americans in Portland to buying or renting homes in the area of North Williams Avenue, which became known as Black Broadway, and the old city of Albina. Over the next two decades, Portland's westside African American institutions were relocated across the river in North and Northeast Portland. This process was accelerated by the economic effects of the Great Depression after 1929 and the closing of the Golden West Hotel in 1931.

In 1922, Beatrice Cannady graduated from the Northwest College of Law, which would later become Lewis and Clark College, becoming the first black woman to practice law in Oregon. Her graduation was a step forward and a step back. She was asked to sing two songs at her graduation ceremony, a fact she was extremely proud of. After her performance, she

was perfunctorily handed her diploma and then she and her invited guests were asked to leave. Her exclusion from the graduation ceremony fueled the beginning of her law career with intense anger. Cannady enthusiastically threw herself into the practice of law and became involved in several civil rights cases, including a case against the Oriental Theater for its refusal to seat her and her sons in the main auditorium. She never passed the culturally biased Oregon bar exam, so she was never officially allowed to practice law in the state, but that never stopped her. Pressure from the Oregon Bar Association to stop practicing law may have partly influenced her decision to leave Portland in 1936.

In 1932, Cannady ran for the state legislature from a Portland district, becoming the first African American to run for public office in Oregon. She gained more than eight thousand votes at a time when Portland's voting black population numbered only about 1,200, showing that she was able to reach voters across racial lines. It was not enough to win a seat in Salem though, and the defeat was personally very discouraging. Cannady was never able to disassociate her personal feelings from her political defeats. There are several reports of her crying bitterly when defeated politically or in court. Many times in the *Advocate* she speaks of the frustration and anger she felt at the persistence of racial discrimination and bigotry. Besides racial discrimination, Cannady faced discrimination for her gender. Many Portland black leaders felt that as a woman, she should take a back seat to male activists. Her highly public profile made her the target of jealousy from both men and women in the black community. Open opposition to Cannady tore apart Portland's NAACP in the late 1920s, and Cannady's leadership became controversial.

In 1936, with her sons relocated to southern California, Cannady had divorced from Edward Cannady and remarried a younger man who had worked for her at the *Advocate*. Publicity about her divorce and her personal life was extremely embarrassing and stimulated opposition to her leadership of the local NAACP. Cannady, like so many Portland activists before and after her, left town. She moved to southern California, where she went into the real estate business with her son and continued to be an activist for racial understanding and mutual respect. She died in 1974 at the age of eighty-four.

Although Cannady has become one of Portland's most forgotten political leaders, her legacy has been great. Her work reaching out to high school and college students helped create a generation of Oregonians skeptical of racial stereotypes and bigotry. Although it often took a personal experience of "eye

opening" to make these young Oregonians take action, their openness to the cultural achievements of African Americans made it a little easier to open their eyes. For example, in 1942, law student Mark O. Hatfield was assigned to escort Paul Robeson, the great singer who had come to Salem for a performance. Hatfield was shocked to find that no hotels in Salem would accept Robeson for the night, and they had to drive to Portland in order to find accommodations for the performer. Hatfield was embarrassed and angry at the slight. He became a leader for civil rights in the state legislature, helping to pass the Public Accommodations Law in 1953 and a whole series of civil rights legislation in the 1950s. As governor and later U.S. senator, Hatfield remained a leader for racial understanding and civil rights.

# PART IV

## *The Most Alien of Aliens*

# THE CELESTIAL KINGDOM
# IN PORTLAND

*If these Chinese are not entitled to the consideration that is bestowed upon the lowest of human beings they ought certainly to be treated as kindly as domestic animals.*
*—J. Taylor*

During the early morning hours of Sunday, December 23, 1872, fire bells tolled in Portland, and the city was awakened to a huge fire along Front Avenue between Morrison and Alder Streets. Historians say that the fire started in a Chinese laundry near the corner of Front and Morrison, but according to Abigail Scott Duniway, witnesses told her that the fire started in a white-owned saloon next door. By the time the alarm was raised, the laundry was burning and the fire had engulfed most of the block on the river side of Front Street. Portland relied on volunteer firefighters, and rival companies sometimes fought over the right to put out fires, but there was plenty of work for everyone this time. By the time the five volunteer companies had mustered, two full blocks on both sides of Front Street were burning.

The out-of-control fire sent fear through the city, and soon hundreds of people were in the streets, many of them in a panic. It had been a little more than a month since sixty-five acres of Boston's downtown had burned in one of the worst urban fires in American history. That fire must have been on the minds of Portlanders as they awoke to the tolling bells and roaring flames. The fire didn't affect Chinatown itself, which was a block or two north of the flames, but many Chinese turned out to pump water from

cisterns and form bucket brigades. There was no shortage of rowdy young men in Portland in the 1870s, and they came out to harass people trying to fight the fire, especially if they were Chinese. There were several cases of Chinese volunteers being beaten and not allowed to take breaks from working. After the fire, there were rumors that three Chinese men had been drowned by young white men. The city blamed the Chinese for the fire, and no one ever investigated the missing men.

It was the worst disaster to strike Portland up to that time; two city blocks were burned to the ground, and there was chaos in the streets. Some residents, afraid that the fire would reach their homes, began throwing their possessions into the street and tried to load them into wagons. This caused traffic snarls all along First Avenue and delayed fire engines from responding to the flames. There were even fistfights, at least one involving a company of firefighters, as people gave in to fear and panic. The chaos that morning made it easy for bigots to take out their feelings on Chinese people, but the brutality was nothing new. Portland's Chinese residents had been the targets of verbal and physical abuse since they arrived in the city in 1851. Visiting loggers, miners and sailors entertained themselves by hazing Chinese strangers, cutting off their long braided queues or even pitching them into the river "to see if they could swim."

The presence of Chinese people in Portland began in December 1851, just months after the city was founded. Tong Sung opened a restaurant and boardinghouse on Southwest Second Street, which was considered out of town in those days. Sung introduced Portlanders to Chinese cuisine. In addition, his boardinghouse provided accommodations for Chinese laborers, who were in great demand. Soon, Chinese residents were working in laundries, cooking and doing other domestic jobs. Sung had come north from the California gold fields, which were already becoming overcrowded in 1851. As the Rogue River and Colville, Washington gold rushes developed in the early fifties, more and more Chinese came north, and Portland became a popular entry point for Chinese immigrants. By 1870, Portland had over seven hundred permanent Chinese residents, out of a total population of about nine thousand. Portland was a transit point for Chinese laborers working all over the Pacific Northwest, so Chinatown could have one thousand or more residents at any given time.

The majority of Chinese Portlanders worked as laborers or domestic help, but there was already a class of Chinese merchants working in the city. In 1868, two men arrived in Portland who both would gain wealth and political power in Chinatown: Seid Back and Moy Back Hin. Both men came from

The majority of Chinese Portlanders before 1900 were young males in their twenties. Most of them worked in service or labor jobs, but a few established themselves as merchants and started families. Large billboards along Second Avenue provided local news as well as news from China and other American Chinatowns. Photo by Arnold Genthe. *Courtesy of U.S. Library of Congress.*

China with humble backgrounds and little material wealth. Like most of the immigrant Chinese, they came to this country with debts to pay for their passage. Some men never managed to pay off all they owed and lived their lives as virtual slaves or indentured servants. Others were able to take advantage of the opportunities available in their new home. Both men were very controversial public figures, and both were accused of crimes, but they were both able to rise above the accusations against them and accumulate great wealth and power.

Moy Back Hin came to America from Guangdong Province at the age of twenty, settling in Portland in 1868. He worked as a laborer for a short time and then was employed in the home of Judge Matthew Deady. Hin respected Deady a great deal and kept a picture of the jurist in his office for the rest of his life. Deady advised the young Chinese man to go into business as a way to secure his future in America. Hin soon opened the Twin Wo

Company, which exported lumber and wheat to China and imported tea, rice, clothing, fireworks and other items. In addition, the company served as a labor broker and provided laborers for the Northern Pacific, Union Pacific and Southern Pacific Railroads, as well as the Oregon Railway and Navigation Company. Chinese laborers were vital to helping Portland exploit its geographic position and become the transportation hub for the region.

Hin benefited from a very profitable business and soon earned the nickname "Portland's Chinese Millionaire." He was generous with his money, making donations to schools in China and in Portland and providing material aid to refugees from the Chinese expulsions and massacres that occurred throughout the 1880s in the Pacific Northwest. In 1906, Hin went to San Francisco to help rebuild the city's Chinatown after the earthquake. Managing thousands of dollars donated by the Chinese government, Hin played a major part in restoring the Chinese district of the city. Partly because of his efforts in the relief of San Francisco, Hin was named Chinese consul to the Pacific Northwest. The fact that the Chinese government chose Portland as the seat of its consul shows the importance of Portland as a port of entry for Chinese immigrants to America.

Hin's appointment as consul was welcomed by white Portland, but the Chinese residents protested. Hin was seen as overly westernized by envious Chinatown residents. The Jung Wah Association, the local branch of the Chinese Consolidated Benefit Association (CCBA), sent a formal protest to the Chinese foreign minister in Washington, D.C. The petition claimed that Moy Back Hin was unfit for the position and should be immediately recalled. Among other accusations, Hin was charged with being a member of the Bow Leong Tong, one of Portland's most powerful secret societies and most effective criminal organizations. Hin was accused of importing Chinese women as prostitutes. Since prostitution was illegal but openly tolerated in Portland and many of the city's wealthiest and most respected residents were involved in the business, at least at some level it would not be surprising if the charges were true. Hin overcame the protests and held onto the consulship until his death in 1935.

Seid Back came to Portland at the age of seventeen, also in 1868, and worked as a housekeeper and cook until he had saved up enough money to go into business for himself. He opened a small general merchandise store, along with a partner, but he concentrated on the labor contracting end of the business, providing laborers for canneries in Astoria and mines in Idaho. At one point, Back went to Idaho, most likely looking for opportunities for the laborers he imported, and ran afoul of the law. There is no record of

the crime that Back committed, but he spent three months in jail and then received a pardon from the governor of Idaho Territory. Back never denied his mistakes, and he was never hypocritical about the realities—and often illegalities—of Portland's business and politics. These qualities made him well liked and respected in both Chinatown and in white Portland.

In the 1890s, Back became part of Joseph Simon's vote-producing machinery for the Republican Party and was a co-defendant in the notorious Lotan smuggling case. Opium was a legal and legitimate product that was in high demand from both white and Chinese Portlanders. When the U.S. customs duty was raised to $12 per pound in 1890, opium became a profitable item for smuggling. Seid Back's store provided a retail outlet, and his labor brokerage clients provided a steady supply of customers. In 1893 and 1894, Seid Back and James Lotan were charged with several smuggling counts and had at least three high-profile trials. Defended by Joseph Simon, Seid Back was acquitted of most charges, although he did pay a $1,000 fine for failing to pay customs duty on $8,000 worth of opium, and in 1894, he was convicted of helping illegal Chinese laborers enter the country. Seid Back was able to overcome his legal problems and remained a popular and prosperous businessman until his death in 1916.

Seid Back and Moy Back Hin both became major property owners in downtown Portland, owning several buildings and even whole city blocks in the original Chinatown (centered on the intersection of Southwest Second and Alder) and in "new Chinatown" (centered on Northwest Fourth and Everett) after the turn of the twentieth century. Both men began families in Portland, and their children, educated at the Baptist Mission School and the Bishop Scott Grammar School, became influential members of Portland's first generation of Chinese Americans, born in this country but still with strong cultural ties to the old world.

The 1872 fire that did severe damage in the heart of downtown Portland was blamed on the Chinese, and opposition to the immigrant community grew in the violence of its rhetoric. Much of the anti-Chinese sentiment came from the newly organizing labor movement. Portland's growing labor community railed against the competition of low-paid Chinese workers and called for the expulsion of the Chinese from American territory. Work camps of farm laborers and loggers on the eastside saw a rise in violence as Chinese bunkhouses became targets of arsonists and bombers. Chinese workers faced hostility and abuse from bands of white workers.

In July 1873, a secret organization, claiming twenty-eight members, slipped anonymous letters under the doors of several prominent Portlanders who

Chinese workers participated in a wide variety of jobs, from doing laundry and growing vegetables to building the Burlington Northern Railroad Bridge, pictured here in 1907. Most of the profit from their work went to the labor brokers who controlled their jobs and their votes. Photo from the Modjeski Collection. *Courtesy of U.S. Library of Congress.*

employed Chinese domestics, including Judge Matthew Deady. The letters, written in red ink in the style of the Ku Klux Klan, which had been getting intense national publicity for the last two years, warned that the members of the organization had united for the purpose of driving the Chinese from Portland and warned that if the Chinese employees of the targeted families were not dismissed, their employers would suffer the consequences. Many people thought the letters were a hoax, especially after young toughs went to the targeted houses and offered to guard them for pay. Thinking the letters were part of an extortion plot, most Portlanders ignored them.

In the early morning hours of Saturday, August 2, 1873, the threats proved to be all too true as the city was once again awakened by clanging alarm bells. The source of Portland's Great Fire was never officially discovered, but most people, including Judge Deady, believed that it had been started by arsonists targeting Chinese-owned businesses. The chaos and destruction of the earlier fire were repeated on a much larger scale as more than twenty

blocks of downtown Portland, stretching from Alder Street to Clay Street and from the riverfront to Second Avenue burned. This time, Chinatown didn't escape the flames, and thousands were left homeless.

Again, brutality against Chinese residents was rampant during the fire, including one incident where a member of the Emmett Guard militia forced a barefoot Chinese man to run along a burning plank at bayonet point, severely injuring the man's feet. Ben Duniway, Abigail's husband, and J. Taylor, of the *Oregonian*, witnessed the incident and provided first aid to the burned man, but the militiaman was never identified. Feeling about the Chinese immigrants became very polarized after the second fire. Wealthy Portlanders, dependent on the cheap labor provided by Chinese workers, were sympathetic and supportive of Portland's Chinese residents. Working people, inflamed by the rhetoric of labor organizers, were violently opposed to Chinese presence in Oregon, and violence increased on the eastside and in small communities throughout the state and Washington Territory.

# THE CHINESE QUESTION

*The Mongolian race in the state of Oregon and territory of Washington are*
*a class of people* [who are] *constant violators of all health and police laws,*
*are immoral, degraded and undesirable in every sense of the word, as well as a*
*constant menace to free institutions; to home and family.*
—*Resolution of the Portland Merchants' and Laboring Men's Anti-Coolie League*

The 1873 financial depression, which was known as the Great Depression until the 1930s, took a while to hit Portland. John C. Ainsworth, Portland's wealthy transportation magnate, used his own resources to bail out the Northern Pacific Railroad so it could reach Tacoma, but the depression delayed Portland's entering the national rail network for another decade. The Northern Pacific went bankrupt shortly after completing the line to Tacoma, and unemployment rose all around the Pacific Northwest. Financial hard times increased support for labor unions, and the 1870s saw several strikes. Portland had a well-established labor movement beginning in 1853 with the Typographical Society, the first labor union in the state. By 1870, Portland was home to five labor unions; most of them, such as the printer's union, represented employees, as well as small employers. By the end of the 1870s, there were more than twenty unions in Portland, and the city had seen strikes of longshoremen and fishermen. Anti-Chinese sentiment remained strong among working people, and many politicians, such as William Thayer, played on these feelings, combined with support for labor rights as a springboard to power.

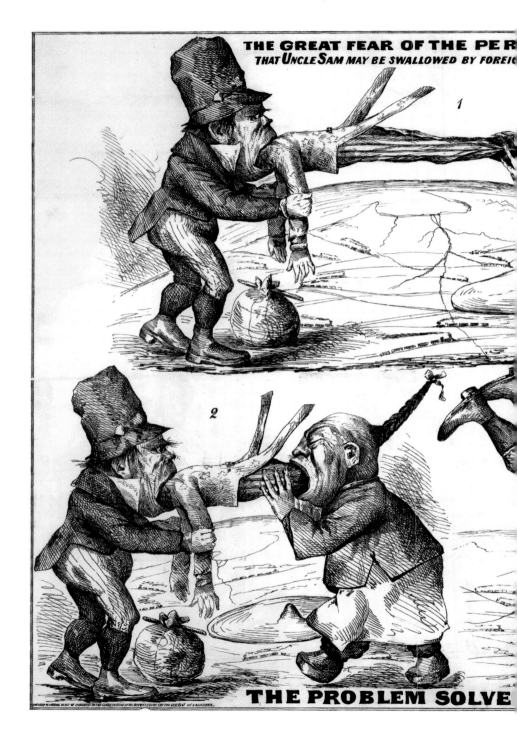

Thayer used anti-Chinese rhetoric in his successful bid for governor in 1878.

The rampant and uncontrolled capitalist system of the nineteenth century created financial panic and depression about every decade. The Panic of 1873 spread unemployment and hard times throughout the Pacific Northwest, but by 1878, things were better. The boom and bust nature of the economy heightened labor unrest. When unemployment was low, unions demanded higher wages; when unemployment was high, the unions demanded an end to wage competition for jobs with Chinese workers. The Chinese were used by employers to keep wages down, especially in the coal mines of Rock Springs, Wyoming, and the Puget Sound. The Chinese, excluded from union membership and even citizenship after 1882, were kept isolated socially and politically. Dominated by powerful Chinese capitalists, they accepted the low wages offered by employers.

The Knights of Labor (KOL), a secret fraternal organization founded in Philadelphia in 1869, had come to fill the vacuum left by the National Labor Union when it collapsed in 1873. The KOL was a conservative labor group, originally opposed to strikes and favoring cooperative relationships with employers, but it provided

Racist images, such as this cartoon from *Harper's Magazine*, were a large part of the anti-immigrant movements of the nineteenth century. Here we see Uncle Sam being swallowed by Chinese and Irish immigrants. Racist fear of the Chinese is shown in the fact that the Chinese immigrant then swallows the Irish. *Courtesy of U.S. Library of Congress.*

a great deal of autonomy for its local organizations, which allowed the locals to choose their own issues. The national organization was an egalitarian group opposed to racial and gender discrimination, but racism, against Chinese on the Pacific Coast and against African-Americans in the South, dominated the local organizations. In 1883, a KOL assembly was organized in San Francisco. Soon there were KOL organizations in Portland, Seattle and Victoria, B.C.

In 1882, Burnette G. Haskell, a California lawyer and newspaper editor, founded the International Workingmen's Association (IWA) in San Francisco. The IWA was formed as a secret conspiratorial group based on Haskell's eccentric interpretation of Karl Marx's ideas. The IWA organized in the form of secret cells, usually with nine members, and soon had organizations all over northern California. The IWA had great success infiltrating Knights of Labor organizations, and it found that the best issue to organize on was Chinese expulsion. Soon Chinese workers were expelled from Eureka and other California communities, and the California Chinese population concentrated in San Francisco.

After the successful expulsion of Chinese workers from Humboldt County in February 1885, David Cronin, a Eureka, California organizer for the Knights of Labor and secret member of the IWA, went to Tacoma, Washington, to infiltrate the KOL local there and test the support for the anti-Chinese campaign in the Pacific Northwest. Popular violence against Chinese became rampant in Oregon and Washington Territory. Chinese miners and agricultural workers from all over Washington Territory began to gather in Seattle and Tacoma for protection.

Violence occurred in Oregon as one hundred Chinese loggers were driven out of Mt. Tabor, Chinese cannery workers were expelled from Albina, agricultural worker barracks near Mt. Scott were burned and more than one hundred Chinese workers were fired from the Woolen Mills at Oregon City. Chinese refugees from all over the area converged on Portland, swelling the population of Chinatown. On September 28, 1885, Cronin and other anti-Chinese leaders called a Territorial Anti-Chinese Congress to order in Tacoma, with representatives from all over the territory. Chinese residents were given thirty days to leave. Chinese refugees began to leave Tacoma in October, many of them heading for Portland. On November 3, the KOL, with the collusion of the mayor and most of the city council, forced Tacoma's remaining Chinese residents into railway boxcars and sent them to Portland. More than seven hundred Chinese residents, about one-tenth of the city's population, were forced out of Tacoma.

Federal authorities swooped in, arresting Tacoma Mayor Weisbach, two city council members and twenty-four other conspirators, including David Cronin, charging them with violation of the KKK Law, passed in 1871 to stop racial intimidation by secret societies. Large anti-Chinese demonstrations and parades occurred almost daily in Portland and Seattle during the winter, and Chinese workers were expelled from Whatcom County north of Seattle. The cities were split between the working class and the owning class. In Seattle, the Opera House Party formed a militia of rich young men, known as the Seattle Rifles, who began military drills in order to protect the Chinese settlement. In Portland, there was talk of a militia, but no evidence that one was actually formed. The city's establishment was against Chinese expulsion, and Harvey Scott and Judge Matthew Deady spoke out against the racist policies of the labor unions.

Portland had long used selectively enforced city ordinances, such as the Opium Smoking Ordinance, Cubic Air Law and the Sidewalk Obstruction Ordinance, to harass and control the Chinese population in the city. Seattle experimented with these laws in early 1886. The Cubic Air Law stipulated that every resident of a building must have a minimum of eight cubic feet of air, effectively limiting the number of occupants a building could have. Chinese lived in extremely crowded conditions, because of the exorbitant rents they were forced to pay, so they were especially susceptible to the law, but no one ever checked to see if white citizens had that much space. When the Tacoma conspirators were acquitted in January 1886, new mass meetings in Seattle called for the "Tacoma Method" to be enforced in Seattle.

On February 7, 1886, 350 Chinese residents who still remained in Seattle were forced aboard steamships, bound for Portland and Victoria, B.C. Trouble broke out between the rioters and the Seattle Rifles, who tried to protect the Chinese Seattleites; three rioters and two militia men were wounded. Territorial governor Watson Squire declared martial law, and President Cleveland dispatched federal troops to Seattle.

Some Chinese immigrants chose to return to China in the face of such violent opposition, but many of them had established lives in America and had Chinese American children. The ones who chose to stay gathered in Portland and San Francisco. In Portland, the population of Chinatown swelled to over five thousand residents, more than a quarter of the city's population. The day after martial law was declared in Seattle, the Portland Merchants' and Laboring Men's Anti-Coolie League was formed at a mass meeting led by Burnette Haskell and David Cronin. Haskell made a fiery speech in which he declared that Portland's Chinese community had thirty

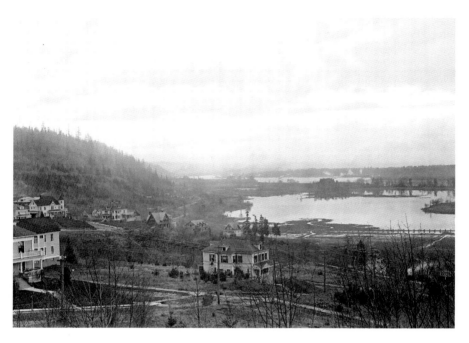

Chinese labor was vital to the development of Portland as a regional transportation hub and an industrial center. Many of the landfill projects that increased the city's buildable area were accomplished by Chinese laborers, such as Guild's Lake, which was partly filled in so the Lewis & Clark Exposition grounds could be built in 1905. Photographer unknown. *Courtesy of Old Oregon Photos.*

days to leave the city. The anti-Chinese movement in Portland had support from a violent radical fringe, but the city's well-established labor unions didn't go for the KOL's divisive tactics.

Violence was widespread, with physical attacks on Chinese in and out of Chinatown and the dynamiting of the Gee Sing Laundry at Northwest Third and F Street (Flanders). Sylvester Pennoyer, a Portland schoolteacher and attorney, made several rousing anti-Chinese speeches and led a few large torchlight parades. Pennoyer was able to ride his popularity and demagoguery into the statehouse in 1886, starting a long and very strange political career. The KOL's reputation for violence and racism led to a major drop in membership over the next few years, and it virtually disappeared from the labor scene in the Pacific Northwest, but its legacy was great. As the first expression of the labor movement in Washington Territory, the KOL inspired a generation of working-class activists who transformed the

state Washington would become in 1889. Newly formed People's Parties in Seattle and Tacoma swept the municipal elections in 1886.

A People's Congress met in Olympia, and the Washington People's Party was founded. The People's Party platform called for many of the progressive reforms that would triumph in Oregon in the twentieth century, such as graduated income tax and the direct election of senators. Although the People's Party platform included an anti-Chinese plank, it also said that "equal duties and responsibilities should receive equal remuneration regardless of race, color, creed, or sex, and we will oppose all efforts to disenfranchise the women of Washington Territory." Over the next decade, the People's Party changed its focus from an anti-Chinese agenda to a more proactive fight for the rights of workers and small businesses, and it became a major power.

Burnette Haskell and David Cronin, realizing that they would not be able to repeat their Seattle success in the more established city of Portland, moved on. Historian Carlos Schwantes concludes that Cronin and Haskell miscalculated the depth of worker radicalism in the Pacific Northwest, but the later success of the Populist movement between 1892 and 1914 casts some doubt on this conclusion. It is more likely that the appeal to racism was understood by many workers as a way to divide their class and dilute their power. This idea became central to the ideology of the Industrial Workers of the World (IWW), founded in 1905, which became a powerful radical force among the working class in Washington and Oregon. In this sense, the conspiratorial nature of the International Workingmen's Association (IWA) makes it more likely that its real purpose was to act as *agent provocateur* rather than as a truly revolutionary group.

The Chinese Exclusion Act severely limited Chinese immigration from 1882 until the 1940s, but the Chinese community in the Pacific Northwest was here to stay. Portland and San Francisco remained the centers of Chinese community on the West Coast, and Portland's Chinese population continued to grow steadily. Political alliances between important Chinese merchants such as Seid Back and Portland's Republican machine ensured that the Chinese community would survive. Efforts of Chinese Americans, such as Seid Gain Back, Seid Back's son and Oregon's first Chinese American lawyer, would slowly achieve civil rights for Chinese and other Asians in Oregon.

# JACK YOSHIHARA

## *Interrupted Lives*

*The war is causing all sorts of worries among the Issei, and nobody can work.*
*We all seem absent minded.*
*—Yasukichi Iwasaki*

The Chinese Exclusion Act of 1882 created a labor shortage for the railroads that Japanese immigrants were happy to fill. There were not many Japanese residents in Oregon, though. Miyo Iwakoshi, the wife of Andrew McKinnon, along with her younger brother, Riki, and her adopted daughter, Tama Jewel Nitobe, arrived in 1880 and settled near Gresham. In 1885, Shintaro Takaki, a traveling salesman, came to Portland to sell Japanese goods to Chinese merchants. He fell in love with the city, or with Tama Nitobe, and he decided to stay. By 1889, he had saved enough money to open a restaurant in Portland, and in 1891, he married Nitobe. That same year, a group of seven Japanese student laborers from Okayama Prefecture came to Portland with the promise of paying for their travel after they found jobs. Arriving in town, they discovered that there were no jobs for them. Discouraged and hungry, they found their way to Takaki's restaurant. Takaki provided them with meals on credit and helped them find jobs on farms and railroads nearby. A few weeks later, a group of thirteen men from Wakayama Prefecture found themselves in the same situation. It was difficult finding work until Takaki met Tadasichi Tanaka of California, who eventually became the most influential Japanese labor broker in the United States. Tanaka

helped the men find positions with the Oregon Short Line railroad, and he asked Takaki for more workers.

By 1896, there were about 600 Japanese railroad workers in Oregon. Portland became the center of Nikkei, as the Japanese immigrant community was called. Workers all over the state spent the off seasons and time between jobs living in Portland. By 1906, the number of Japanese railroad workers in the state doubled to over 1,200, and they made up 40 percent of the total railroad workforce in the state. Like the Chinese immigrants before them, they were mostly young men. Some of them planned to learn what they could in America and return to Japan, but some of them were looking for a new life in the land of freedom. Averaging about thirty-five dollars per month, significantly less than Euro-American workers were getting, they paid back their travel debt, paid as much as 10 percent of their income to a labor contractor, paid inflated prices for necessities in company stores and still they managed to save money. They did it by starving themselves and catching their own food. One Issei, as the first generation of Japanese immigrants were called, remembered, "In those days a stray jackrabbit meant a feast and a cow killed by a passing train was a God-sent banquet."

Some found jobs as houseboys in the wealthy neighborhoods of Portland. These men had fewer expenses and time to attend school. Within a few years, many of them had started businesses in Portland to cater to the Japanese community. Japanese barbershops, hotels and restaurants flourished, and they attracted clients of all races. The majority of Japanese-owned restaurants in Portland served "American food" and catered to a white clientele. Japanese hotels in Portland were never considered to be of the highest class, but they dominated the market in cheap hotels for people of all races. Early in the 1890s, the flourishing community attracted a group of Japanese gamblers and prostitutes who had first come to Seattle; by 1893, one report counted over forty Japanese gamblers and pimps and nineteen prostitutes in town. Most of the Issei were from agricultural backgrounds, and they dreamed of owning land. In 1903, many of the railroad labor contracts ended, and most of the workers moved on to agricultural jobs. Many of them were able to put small payments down on land of their own.

In Polk County, hops was the main crop, but most Japanese farmers grew vegetables or fruit. Russellville, now the Portland neighborhood of Montavilla; Gresham-Troutdale; and Hood River became centers for Japanese farming. Japanese lumber mill and cannery workers settled in Astoria, and a small Japanese community in Marion County pioneered growing and marketing celery. By 1910, Nikkei in Oregon were farming over 4,600 acres, supplying

70 percent of Portland's fresh produce and most of the state's strawberries. The Issei who had come to Oregon as student laborers were mature men by this time and ready to start families. Some of them, like Renichi Fujimoto, worked for years to bring the women they loved from Japan; others ordered "picture brides" from catalogues. Soon, a new generation, the Nisei (second generation), were born. Although their parents were banned from citizenship by law, the Nisei were American citizens by birth.

The Issei faced discrimination nearly as bad as that faced by the Chinese workers they had replaced. In 1907, anti-Japanese sentiment on the West Coast led President Theodore Roosevelt to conclude the "Gentlemen's Agreement" that he would not support Japanese exclusion and the Japanese would limit immigration. After 1907, the Issei who came to Oregon were better educated, often professionally trained and much more interested in settling permanently in America. Many communities in Oregon formed Anti-Asiatic Leagues and growers' associations determined to keep the Japanese immigrants out. Japanese were discouraged from settling in most of the counties of Oregon, and by the 1920s, anti-Japanese activism soared with the rising power of the Ku Klux Klan and their allied organization, the American Legion (AL). The KKK, ranks swelled by Great War veterans who were also members of the AL, achieved great political power in most areas of Oregon with its "100% American" campaign preaching family values, political reform, prohibition and white supremacy. The KKK/AL alliance beat the drum of Japanese exclusion and even expulsion; in 1925, thirty five Japanese lumber mill workers were forcibly evicted from Toledo, Oregon, by an angry mob of over three hundred people. The Japanese workers had been brought to the Oregon coast logging town as strikebreakers, a tactic that employers often used to keep wages down in the Pacific Northwest.

Nikkei in Oregon developed into a very tightly knit and socially conscious community. Organized to defend their rights, they always tried to stay as non-threatening as possible. Faced with racist fear, they could never be non-threatening enough, but they tried. They also took care of each other. After the stock market crash of 1929, the Nikkei were hurt as much as any other community, but very few of them received relief or government sponsored work, even during the New Deal. By 1930, there were nearly five thousand Japanese Oregonians, the majority of them in Portland. More than one-third were foreign born and ineligible, under the 1924 Immigration Act, to own property or to become citizens.

By 1941, the Issei who remained, now entering their sixties, kept their Japanese identity, but they had fully embraced American values and beliefs.

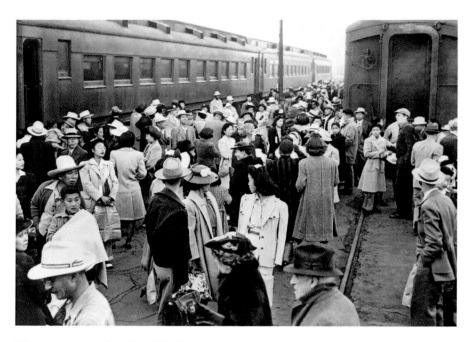

The Japanese attack on Pearl Harbor in 1941 created great confusion and fear among Portland's Japanese American community. The internment that began in May 1942 disrupted their lives and left them impoverished. Photographer unknown. *Courtesy of U.S. Library of Congress.*

Their children were citizens, and their future was American. War between Japan and the United States created a huge traumatic shock for Nikkei. The Issei were frightened and confused, afraid that their property and even their lives were at risk. For the Nisei, the experience was different.

The first generation of Japanese American citizens was reaching adulthood in 1941. The Nisei in Portland had become extremely Americanized. Most of them attended the public schools and participated in local cultural events such as the Rose Festival. Young Japanese Portlanders had grown up during the first American experiment in mass culture. Beginning with the age of yellow journalism, which exploited images of sex and violence to appeal to a mass audience, before the Great War the media had grown in scope and power. With the advent of radio beginning in the 1920s, the decade in which many of the Nisei were born, and the growing influence of motion pictures, the young generation had been bombarded with images of what it meant to be American. They listened to swing music; they went to the movies and the soda fountain. They liked hamburgers and fries. Most of all, the young men

played sports. The Portland Midgets was a popular basketball team featuring players such as Henry Shimojima and John Murakami; the Iwasaki brothers from Hillsboro, Akira "Ike" and Arthur, played basketball and baseball; Jack Yoshihara's sport was football.

Jack Yoshihara was born in Japan in 1921. His father, Hideichi Yoshihara, and mother, Kotoyo, had already spent time in Portland but had returned to Japan while pregnant to care for Kotoyo's mother, who had become ill. By 1923, Hideichi was back in Oregon, where he worked in canneries and farmed. In 1924, Kotoyo and Jack rejoined him, and the boy was raised in Portland. Jack attracted attention as a football player for the Benson High School team in 1939, and the next year, at the age of nineteen, he entered Oregon State College (OSC) at Corvallis. In fall 1941, Jack was a sophomore reserve on the Beavers football team, playing left end. OSC, which changed its name from the Oregon Agricultural College in 1937, had fielded a football team since 1893. The Beavers, although they usually had a good win-loss record, never attracted a lot of attention until Alonzo "Lon" Stiner became coach in 1933.

Lon Stiner would coach the Beavers until 1949, taking the team to two Pineapple Bowls in Hawaii (1940 and 1949) and the Rose Bowl in 1942. When Stiner retired, he had a perfect record of bowl game wins. In 1940, when Jack Yoshihara first went out for the team, the Beavers had just finished their most successful year up to that time, beating the University of Hawaii Rainbows 36 to 6 on New Year's Day. With their great season in 1939, the Beavers had only been able to take second place in the Pacific Coast Conference (PCC), but in 1941, with Jack Yoshihara and several of his Benson High teammates as reserve players, they took first place and qualified for the Rose Bowl for the first time. The game was scheduled to play in Pasadena on New Year's Day 1942.

December 7, 1941, changed things. It was early Sunday morning when news of the Japanese air raids on Pearl Harbor and Manila and the occupation of Wake Island reached Portland. The mouth of the Columbia River is the closest point to Japan in the lower forty-eight states. Fear and confusion gripped the city, but the hysteria that reigned in California in the days after the bombing never hit Portland. President Franklin Roosevelt imposed strict limits on "enemy alien" residents. They were not allowed to withdraw more than $100 from a bank; they were not allowed to conduct business or ride on public conveyances. In addition, military and police guards were placed on all bridges, shipyards, docks and other strategic spots. The FBI was ordered to start rounding up one thousand Japanese nationals

who had been identified as "troublemakers." Strict blackout regulations shut down radio broadcasts from 7:30 p.m. until 8:30 a.m. and made it illegal to display lights between the hours of midnight and 8:00 a.m.

By Tuesday, twenty-four Portland Japanese residents had been arrested, along with twenty-five Germans. The Issei were banned from traveling more than three miles from home without authorization, and restricted items, such as samurai swords and cameras, were seized. Jack Yoshihara, having been born in Japan, was classified as a Japanese national and lost his camera. He did not get it back until December 1945. Fiorello LaGuardia, mayor of New York and national director of Civil Defense, came to Portland and declared that the West Coast was in grave danger. He conferred with Mayor Earl Riley and made plans for the distribution of gas masks and other air raid equipment in Portland. He also reviewed the city's defenses; more than two hundred police reserve officers had been called up in the Veteran's Patrol in order to guard strategic city assets. Although the KKK only survived as an underground fringe group, the American Legion was still strong, and many members of the Veteran's Patrol were AL members.

Jack was allowed to stay in Corvallis until the end of the school year. The Rose Bowl game was played outside of Pasadena, California, that year for the first time; it was hosted by the Duke University Blue Devils, who OSC beat 20 to 16. The game was moved because President Roosevelt had banned all large public gatherings within two hundred miles of the Pacific coast. As a Japanese national, Jack Yoshihara was restricted from traveling, and so he didn't get to play. For a time, his teammates planned to smuggle him to North Carolina in their luggage, but at the last minute, he decided to stay home. He received a game jacket, and in 1985, he was awarded a Rose Bowl ring, but his football and college career were badly derailed. In April, when the president's order to evacuate Japanese and Japanese American residents within two hundred miles of the coast went into effect, Jack's family was interned, along with more than three thousand others, in the Portland Assembly Center (PAC).

The PAC was a converted cattle barn where the Portland Expo Center is now located. Hastily built cubicles went up inside the barn, and Japanese Americans from all over Oregon and Washington were gathered there before being sent to relocation camps in Idaho and other states. At the end of the school year, Jack joined his parents at the PAC, and later that summer, they were relocated to the concentration camp at Minidoka, Idaho. College-age Japanese internees were encouraged to finish school, and in 1943, Jack entered the University of Utah, where he played quarterback and fullback.

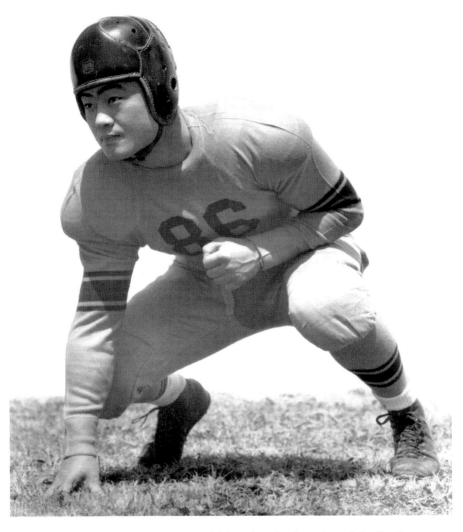

In 1941, Jack Yoshihara was a student at OSC and a valued member of the first Beaver football team to qualify for the Rose Bowl. December 7, 1941, changed Jack's plans when he was not allowed to play in the Rose Bowl and then interned so he could not finish his education. Photographer unknown. *Courtesy of Oregon Nikkei Endowment, Portland, OR. Object no. ONLC00542. Gift of Jack Yoshihara.*

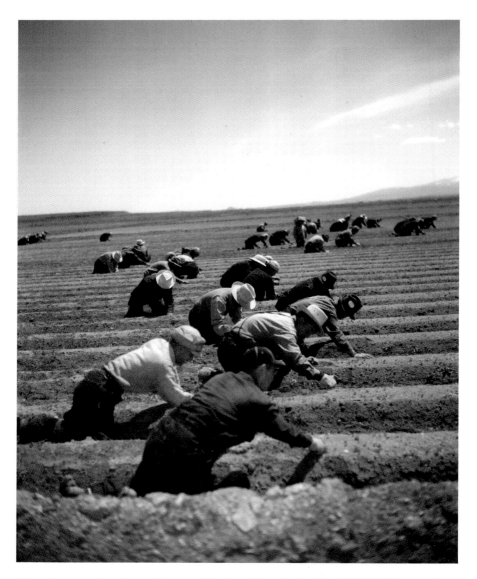

Many Japanese Americans volunteered for the military during World War II. The 442nd Infantry Regiment, which saw action in Europe, became the most decorated unit in U.S. Army history. Others volunteered for civilian work, such as these farm workers near Tule Lake, California. Photo by Lee Russell. *Courtesy of U.S. Library of Congress.*

He had a good football season, playing in every game for U of U, but he was badly injured near the end of the season. His injury kept him from playing football for the rest of his life, and it also kept him out of the army when it opened Japanese American enlistment in 1944.

Many Portlanders, such as Akira "Ike" and Arthur Iwasaki and eighteen-year-old Bill Naito, entered the army and served in the 442nd Combat Regiment. The 442nd served in Italy and Germany during the war and became the most decorated unit in U.S. Army history. The 442nd, whose regimental motto was "Go for Broke," was made up of soldiers of Japanese descent with only a few Euro-American officers. The members of the 442nd fought with distinction while their parents languished in relocation camps far from their homes. The 442nd received eight Presidential Unit citations and twenty-one of its members received the Medal of Honor. So many of the unit's men were wounded that it was called the "Purple Heart Battalion." For example, Art Iwasaki received three purple hearts and a Bronze Star himself. Jack Yoshihara took more than a year to recover from his injury and eventually finished his education at Multnomah College after the war, completing a technical degree in refrigeration at the school's Swan Island facility, where he worked as an instructor for several years. He was awarded an honorary degree from the Oregon State University in 2004, when he was eighty-two years old.

Through the efforts of attorneys such as Minoru Yasui of Hood River, who graduated from University of Oregon Law School in 1939, becoming the first Japanese American lawyer in Portland, slowly the wartime anti-Japanese laws were challenged and overturned. Yasui had been convicted of breaking curfew in 1942 and finally had his conviction overturned in 1986, the same year he died. In 1982, President Jimmy Carter created the Commission on Wartime Relocation and Internment of Civilians (CWRIC), which ruled that the Japanese relocation had not been justified. The Civil Liberties Act of 1988 authorized "redress payments" for Japanese Americans who had been interned during World War II; former internees received checks and letters of apology. In 1993, President Bill Clinton publically apologized for the internment.

# PART V

*The Problems of Self-Government*

# POLITICAL WARFARE

*If God almighty should come to the city during...[a] campaign and try to work against the schemes and combinations of practical politicians, he would lose the fight.*
*—Charles K. Henry*

Whether pioneers crossed the plains on wagon trains or took the long voyage by sea, the main motivations for coming to Oregon were land and self government. From the "Wolf Meetings" in Champoeg that set up the first Oregon Provisional government to the entry of Oregon as a state in 1859, the history of Oregon's Euro-American community was dominated by the struggle for self government. After a series of public meetings, the city government of Portland was set up and chartered in 1851. The early government of the city developed by trial and error as the city charter was revised and a succession of short-term mayors bumbled through their terms. When Josiah Failing was elected in 1853, a pattern was set that would stay with the city for generations in which the city was governed by an elite group of merchants and businessmen who guided Portland's development and growth to suit their own needs and goals. Although many of the early political leaders were Democrats, there was a strong influence from the Whig Party, which was conservative and business-oriented.

The territorial and early state governments were controlled by proslavery Democrats, known as the "Salem ring," led by Asahel Bush, editor of the *Oregon Statesman*. The Democratic Party maintained tight discipline on

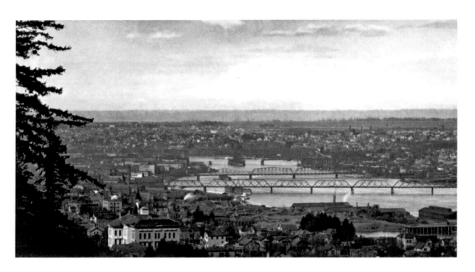

The 1860s through the 1890s saw incredible growth of the city of Portland. Local politicians, both Democrats and Republicans, considered the city's best interests and their own to be the same. Graft, corruption and political manipulation were standard operating procedures. Photograph by Herbert Hale. *Courtesy of Old Oregon Photos.*

the slavery question, expelling anyone who showed the slightest tendency toward abolition. This policy of stifling dissent led many Democrats, such as James Nesmith and George Williams, to gravitate toward the Republican Party, which gained great power in the state during the Civil War. The Republican Party of Oregon was founded at a convention in Albany in 1856 and had a hard time getting off the ground in electoral politics. The Republican candidate for Congress, David Logan, was consistently beaten by Democrats, but Edward D. Baker became the first Republican senator from Oregon in 1860.

Baker, a former congressman from Illinois and a good friend of President Abraham Lincoln, led troops during the Civil War and was killed at the Battle of Ball's Bluff in 1861, the only sitting member of Congress to be killed in battle. Baker was an important progressive politician; he is credited with convincing Abigail Scott Duniway of the importance of women's suffrage. His death allowed Oregon Democrats to appoint Ben Stark as senator. The Democrats held onto control of the senate for several years, but the war had produced a split that doomed the prospects for the Democratic Party in Oregon.

In Portland, the split was between the Union-Democrats, such as James Lappeus, who would soon be the city's first police chief, and Anti-war

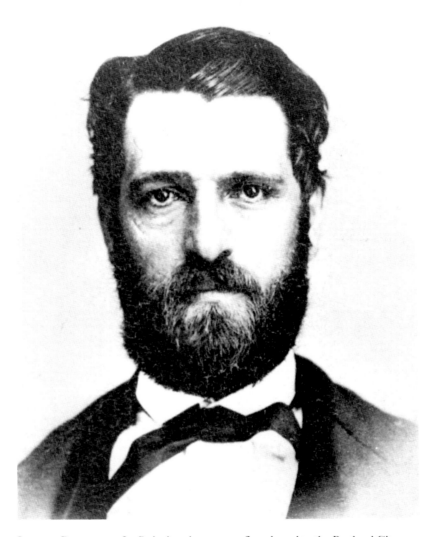

Lucerne Besser, son of a Swiss immigrant, was first elected to the Portland City Council in 1867. He used whatever means he could to bring down his rival Police Chief James Lappeus and seize control of the Portland Police Bureau for the Republican Party. His success in 1883 brought about his own downfall. Photographer unknown. *Courtesy of Portland Police Historical Society.*

Democrats, called Copperheads by their enemies, led by Bob Ladd. Political campaigns in nineteenth-century Oregon took on personal dimensions, and a drop in political fortunes could mean personal disaster. Bob Ladd (no relation to William S.) was hounded out of his public positions, charged with embezzling money and run out of town, eventually becoming a fugitive hunted down in the hills of Southern Oregon. Clearly, losing a political battle in Portland could destroy someone's life.

Lappeus's Oro Fino Ring, named after the luxurious saloon and theater owned by the new police chief, tried to hold onto power in the city. They managed to control the police department, with help from Democratic governor Lafayette Grover who appointed Portland's police commission. Lappeus's enemies claimed that he used the police force and a group of special officers hired to police elections to discourage Republican voters and to stuff the ballot boxes with Democratic votes. The Republican Party was torn by a split of its own, between the moneyed interests of Henry W. Corbett and the new "progressive" strain of the party led by John H. Mitchell and Ben Holladay. The fight over control of the police department in Portland was led by city councilman Lucerne Besser, an ally of Corbett.

Lucerne Besser, born in Buffalo, New York, was the son of a Swiss immigrant. He came to Portland in 1852 and worked in the lumber business, setting up and running more than one lumber mill. Besser was elected to the city council in 1867 and remained involved in city government until the 1880s. His career as a city council member was accompanied by controversy and dominated by a feud with James Lappeus that at times seemed to be highly personal. Besser was involved in the street improvement committee from his first term on the council, and he made a great deal of money by awarding street contracts. Like most of the city politicians of the time, Besser used his position to promote his personal interests, and he was involved with bribery and graft on several occasions. Fortunately for historians, Besser was careful to document many of his dirty dealings, even collecting a signed receipt from Mayor James Chapman, whom he bribed in 1883. The documentation that Besser kept led to his downfall; he was indicted for corruption in 1883, and his political career ended at that time.

Like many of Portland's politicians, Besser was not shy about accusing his enemies of graft and corruption. Lappeus, who probably accepted bribes from murderers to let them escape and was known to use the police department to advance his own interests as a saloonkeeper, was vulnerable to Besser's charges and was removed from office in 1877. Besser replaced Lappeus as police chief, but Lappeus's eclipse didn't last long, and he was

back in charge by 1879. Besser kept up the pressure on Lappeus, and in 1883, the bribe that he paid to Mayor Chapman was partly for the purpose of getting Lappeus fired once again. Lappeus was vulnerable because of his corrupt dealings during the so-called Cary Bradley case, a cold-blooded murder involving a notorious house of prostitution. Lappeus was charged with accepting a bribe from Bradley to allow her and her accomplices to leave town without being arrested. He had no real defense against the charges and was soon out of the Portland Police Bureau for good.

Besser's success was his undoing. The corrupt deal he had made with Mayor Chapman came out, and the mayor was disgraced. Chapman, a respected doctor who had served as mayor twice before, had fallen on hard times during the depression that hit the city in 1883. With his $1,500 mayor's salary as his only income, Chapman was vulnerable to Besser's bribe of $1,000 down and $1,000 per month. The mayor was impeached and admitted taking the bribe, but he was not removed from office, serving out his term as a lame-duck. In December 1885, just a few months after leaving office, Chapman was killed when he drove his buggy under a low-hanging telephone wire. The wire caught him by the neck and threw him to the road. Besser was indicted for bribery and spent the rest of his life locked in legal battles that led to dire poverty. In 1900, living in the Multnomah County poor farm and ill, Besser was involved with a plot to forge the deed to property worth $200,000. The deed, supposedly signed by Lewis Love before his death, was proved to be a document he had signed twenty years before. Someone erased the original contents of the document, written in pencil, and filled in the contents of the deed over Love's signature. Once the document was proved to be false, the investigation stopped, so no charges were brought against Besser. He died in 1905, still a poor farm resident.

Ben Holladay, who had bankrolled John Mitchell's political activities, went broke in the 1870s, but Mitchell consolidated his hold on both the Republican Party and the state legislature. In 1873, Mitchell was elected to his first term as U.S. senator. He lost his bid for reelection in 1879 to Democrat James Slater, but it was only a temporary setback. Mitchell was reelected to the senate in 1885 and served, with a short break in the 1890s during the worst political struggles, until his death in 1905. In 1880, the Republican Party gained control of both houses of the state legislature, keeping control of the Senate until the 1950s and the House until the 1930s. John Mitchell and his law partner Joseph Dolph, who served in the U.S. Senate from 1883 until 1895, were the undisputed leaders of the Republican Party, although they rarely agreed with each other.

The Republicans complained loudly about the corrupt election practices of the Oro Fino Ring and the Democratic Party, but they used the same tactics to bring in the vote. Jonathan Bourne Jr., a local man-about-town and mining investor, and Joseph Simon, a law clerk in the firm of Dolph & Mitchell, became the architects of a political machine that controlled the vote in Portland for more than thirty years. Bourne, the black sheep of a wealthy New England family, was famous for his drinking and gambling. After coming to Portland in 1878, he developed strong contacts with the underworld and used those contacts to deliver the vote in the North End. The North End was the home of sailors and other transient workers and an area where gambling and prostitution were allowed to flourish, despite laws against both practices. Bourne, through connections with men like sailor's boardinghouse keeper Larry Sullivan, was able to deliver a solid and dependable vote for Republican candidates.

Joseph Simon, son of a Jewish German immigrant who came to Portland in 1857 when Joseph was six years old, attended public school and was elected to Portland City Council in 1877. Young Simon soon gained a reputation as an efficient politician. In 1880, he was instrumental in the Republican capture of the legislature, being elected to the state Senate and becoming chairman of the state Republican Party. Simon remained in the Senate for eleven years, and during that time he developed the vote-getting machine in Portland to a high degree of efficiency. Like many American "machine politicians," Simon courted the votes of minority groups, working with men like Julius Caesar to deliver the African American vote and Seid Back to deliver the Chinese American vote. By the mid-1890s, when Simon challenged Mitchell's power, he had become the most powerful Republican in the state.

The Republican Party, secure in its electoral power, took full advantage of its position. Mitchell, Dolph and Simon used their positions to enrich themselves, as did most of the people involved in Portland's city government during the 1880s and 1890s. James Lotan, an ally of Mitchell and a friend of Simon, provides one of the most blatant cases of corruption during the time. Lotan—born in Paterson, New Jersey, in 1843—completed an apprenticeship as a machinist before serving in the New York Volunteers during the Civil War. After his enlistment, he began working on naval steam engines and eventually came west, settling in Portland in 1865. Lotan worked his way from shop foreman to company owner in less than five years. Building and maintaining steam engines put him in a perfect position to make connections among railroad and steamship circles. His connections

1. *Judge Bellinger.* 2. *Ex-Inspector J. H. Coblents.* 3. *Nat Blum.* 4. *William Dunbar.*

James Lotan's trial for smuggling and conspiracy while he was collector of customs was highly embarrassing to the Republican Party, of which he was chairman. Drawing from the *Morning Oregonian. Courtesy of Offbeat Oregon History.*

and his activity with the Republican Party created many opportunities for the ambitious young man.

Lotan acquired a half interest in the obsolete Stark Street Ferry in the 1880s. By that time, the new bridges had taken most of the ferry's traffic, and the vessel had become very run down. When the cities of Portland, East Portland and Albina combined into one city in 1891, Lotan tried to make a deal to sell the old ferry, but he wanted $50,000 for it, which was more than ten times its value. Lotan used the tactic of opposing popular city initiatives, such as the merger, in order to get his payoff before letting it go through. In 1891, it won him the plum position of collector of customs. In 1892, Joe Simon, who had been leader of the state Republican Party for nearly twelve years, moved up to the National Committee. James Lotan took his place as head of the state party. Finally, he had the leverage he needed, and in a settlement over the Bull Run Water Project, Lotan convinced the

city to pay $40,000 for his ferry. It wasn't as much as he wanted, but he was supplementing his income by using his customs position to smuggle illegal opium and Chinese workers into the city.

It was embarrassing for the Party, and for Lotan personally, when the scandal broke in 1893. Twenty people were indicted in the conspiracy, and Lotan was charged with several counts of illegal activity, as was the prominent Chinese merchant Seid Back. Lotan was an ally of John Mitchell, so the Simon faction, challenging Mitchell for power, kept the scandal brewing through 1895, destroying Lotan's political power. With fellow Arlington Club members on the jury and ex-law partners on both sides of the case and on the bench, the good old boys of Portland managed to make Lotan's legal problems disappear.

The Panic of 1893 hit Portland hard as several banks went under and unemployment became a serious problem. The financial depression created a new split in the Republican Party that Joe Simon could exploit. The split revolved around the issue of the free coinage of silver. The dollar was based on the gold standard, and free silver promoters, known as Silverites, supported the inflationary policy of bimetallism; basing money on both silver and gold. The free silver idea gained great support from cash-starved working people and small farmers who saw it as a way to get more money into circulation. The so-called Progressive Republicans of the 1870s, such as John Mitchell and Jon Bourne, became Silverites. Joe Simon and Henry Corbett represented the conservative business wing, the Goldbugs. Simon saw his chance to push his rival out of power.

With secret infusions of gold from his good friend Sigmund Frank, of the Meier & Frank Department store, Henry Corbett was able to keep his First National Bank afloat and continue to fund dirty tricks and vote buying for the Republicans. "Little Joe" Simon, who had been president of the state Senate for more than a decade, had developed his political machine along statewide lines, and Bourne's local operation couldn't compete. Corbett and Simon delivered the vote for McKinley, but Portland went Democrat and the People's Party showed surprising strength.

John Mitchell, with his opportunistic ethics, was his own worst enemy. U.S. senators were not elected at the time; they were appointed by the state legislature. Thus, the campaign for legislators was the real Senate campaign. In 1896, faced with open opposition from Simon, Mitchell allied with the Democratic Party on the issue of Free Silver. Jon Bourne, one of the most important mining investors in the Pacific Northwest, had a great interest in the Free Silver issue, and he joined Mitchell in his defection. The

election was hotly contested, and the People's Party won significant support, outnumbering the Democrats in the legislature.

Before the legislature could meet and appoint Senator Mitchell for another term, he arrogantly admitted that he had no intention of voting for free silver. Jon Bourne felt betrayed and determined that he would stop Mitchell. He couldn't win the vote, so he had to stop the legislature from meeting. Allying with William U'Ren, leader of the People's Party, he put together a simple plan. U'Ren and the Populists would delay all business, and Bourne would provide a diversion to keep members away. If they were successful, the legislature would never be called to order and no Senator would be named. Bourne, with help from his friends in the North End, outfitted an apartment in the Keller House on State Street, just blocks from the Capitol. There, in a forty-day party known as "Bourne's Harem" or "the Den of Prostitution and Evil," depending on which side you were on, Mitchell's hope of reelection died. The alliance between Bourne and U'Ren would become important to the future of politics in Oregon, but the short-term beneficiary was "Little Joe" Simon. After a short time of dispute, he emerged as Oregon's U.S. senator in 1898.

# THE OREGON SYSTEM

*Good government is a religion to us.*
—*Seth Luelling*

The Panic of 1893 was the worst of the regularly occurring economic depressions that struck Oregon before 1929: banks failed, mortgages were foreclosed and unemployment rose. By 1894, there were approximately four million unemployed in the United States. In Portland, unemployed migratory workers gathered along Skid Road (Burnside) and struggled to survive. By 1890, there was a well-organized labor movement in Portland with at least eight craft unions listed in the city directory. The Central Labor Council had done a good job integrating the unions into the city, and they drew a great deal of support from middle-class Portlanders. In 1890, when the two carpenters unions in town joined the national strike for an eight-hour day, support from the middle class and even some of Portland's elite, such as C.E.S. Wood and Harvey W. Scott, was important in turning it into a general strike. Although the eight-hour day was not achieved in 1890, the alliance between working-class and middle-class Portlanders was forged and became even more important as time went on. Historian Robert D. Johnston has done groundbreaking work on this important political alliance.

The alliance was formalized when the Oregon People's Party was founded in 1891. In April 1894, Coxey's Army, the first attempt to organize unemployed workers, came to Portland. On April 16, sixty unemployed men from San Francisco and southern Oregon arrived in Portland and

THE DEMOCRATIC MICROBES.

Puck. —Gentlemen, we have here the most dangerous germs in the body politic.

Health and disease were common metaphors for Progressive and Reform politicians. In this satirical *Puck Magazine* cover from 1904, we see it applied to the infiltration of the Democratic Party by the Populists. *Courtesy of U.S. Library of Congress.*

set up camp in Sullivan's Gulch. They established a recruiting station on West Burnside and began to hold daily rallies in the Plaza Blocks. Soon, more than five hundred unemployed Portlanders had joined up and were preparing to march on Washington, D.C., where unemployed protestors from all over the country were meeting to demand public jobs and loose monetary policy. The protestors received plenty of material support from the sympathetic community, but they were unable to obtain transportation from the Northern Pacific Railroad. On April 25, the army marched east to Troutdale, and a few days later, they commandeered a train to take them to Washington.

They were stopped by U.S. Army troops at Arlington, up the Columbia, and were returned to Portland, where most of them were confined in freight cars in the Albina rail yard. The support was immediate; rallies in the Plaza Blocks drew 1,500 supporters the first day and 3,000 the second. Out-of-state protestors were returned home, and the movement collapsed. Very few Oregonians made it to the capitol, but the organizing that occurred swelled the ranks of the People's Party. In 1896, the Democratic Party made an alliance with the People's Party, and the combined forces took advantage of the split in the Republican Party to elect ex-governor Sylvester Pennoyer as Portland's mayor. The People's Party elected sixteen legislators and three senators to the state legislature, including their powerful leader William S. U'Ren.

William U'Ren, born in Wisconsin in 1859, came to Oregon by way of the mining region of Colorado. His political education began in the mines, an important source of radical political ideas among the working class. While working in the mines, he attended law school at night, becoming an attorney before moving west. He became a believer in the Single Tax—a plan that kept the majority of real estate value in the hands of the community—and in an effort to bring the system to Oregon, U'Ren led the political fight that introduced the Oregon System of direct democracy. The Oregon System included reforms such as the ballot initiative, referendum, direct primary, popular election of senators and recall elections. Although U'Ren never managed to pass a Single Tax amendment, his reforms transformed government in Oregon and eventually spread to most of the states of the union.

U'Ren's success began in 1891 with the passage of the "Australian Ballot," which provided preprinted and secret ballots. The People's Party was soon absorbed into the Democratic Party, but U'Ren's People's Power League (PPL) became a powerful voice in the state. The PPL was a leader in passing

the Initiative/Referendum amendment in 1902, initiating an important period of direct democracy in Oregon. Oregonians decided on twenty-three initiative campaigns in the first decade. These campaigns dealt with issues such as women's suffrage, Prohibition and capital punishment and overturned unjust laws, such as the first Eugenics Law. Local initiatives, which were introduced in Portland in 1904, were even more numerous; Portlanders voted on 129 different municipal matters in the first decade. In the early twentieth century, the PPL allied itself with the new Progressive Party, creating an even more powerful alliance between Democrats and progressive Republicans.

After Pennoyer's term as Portland mayor, the Republicans under ex-senator John Mitchell reestablished control over city government. Working through his allies Police Judge Charles H. Carey and U.S. Marshall Jack Matthews, Mitchell had taken control of the Portland Republican machine, electing a series of ineffective mayors and gaining reelection to the U.S. Senate in 1901. The Carey-Matthews machine ushered in the worst period of corruption and graft in Portland history. Between 1898 and 1905, the city went through an intense expansion with the erection of the second Madison Street Bridge and the new Morrison Bridge. In addition, the Portland Consolidated Street Railway Company gained a monopoly on local transportation, and sewer and street paving contracts abounded. Graft and corruption on these projects siphoned funds from the city into the pockets of Mitchell Republicans, while the underfunded Portland Police Bureau and fire department cut services. Mitchell's reign ended with his conviction for bribery during the Land Fraud Trials of 1905 and his sudden, timely death.

The open graft and corruption of Portland's city government, combined with the personal rivalry between John H. Mitchell and Jonathan Bourne, fueled the Progressive campaign of Democrat Harry Lane. Lane, a physician from Portland's eastside and a member of the PPL, was a Democrat, but he drew large support from the newly formed Progressive Party. Lane was born in Corvallis in 1855, the grandson of Joseph Lane, Oregon's first territorial governor and a famous Indian fighter. As a young man, Lane had become friends with several local Native Americans. The relationships he developed became highly influential on his political beliefs, especially Indian ideas about community and the individual's responsibility to it. Later, as Oregon's first popularly elected U.S. senator, Harry Lane became a national leader for Native American rights, environmental protection and anti-Imperialism; he was one of six senators who voted against U.S. entry into the Great War.

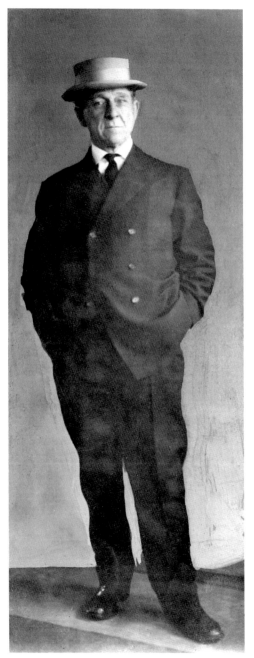

The Progressives were able to elect a mayor, but the ward system of electing city council members allowed the Republican machine and the "liquor interest" to keep control. Lane was a popular leader and became an important symbol of resistance, but as mayor, he was left powerless in the face of a city council that overrode his veto 90 times in his two terms; he used his veto pen a total of 169 times in four years. He led the city by example, personally inspecting public works projects, making contractors meet his standards and leading popular initiative campaigns on local issues. In 1909, the last year of his term as mayor, there were a record thirty-two initiative proposals on the ballot. Senator Joseph Simon, the old Republican boss, was elected mayor that year, but Lane's initiatives had created a great deal of transparency in how the city did business. Popular disgust at continued corporate control

Dr. Harry Lane, the grandson of General Joseph Lane, was known as the "poor people's doctor," before becoming mayor of Portland in 1905. The alliance between the Progressive Party and the Democratic Party carried him into the U.S. Senate in 1913, the first Oregon senator to be elected by popular vote. Photographer unknown. *Courtesy of U.S. Library of Congress.*

The powerful Progressive-Democrat alliance revived the power and organization of the Democratic Party after the debacle of the Civil War. Oswald West, who became governor in 1911, was one of the beneficiaries. West ushered women's suffrage into Oregon, but he also brought Eugenics Laws and Prohibition. Photographer unknown. *Courtesy of U.S. Library of Congress.*

led to the new commission city government, which elected the city council at-large and improved representation of the working-class eastside.

As mayor, Harry Lane took the lead in expanding women's rights in Portland. He led the nation in appointing women to public office: Dr. Esther Pohl Lovejoy became city health director, Sarah Evans became the city's first female market health inspector and Lola Baldwin became the city's first female police detective. He presided over the 1905 Lewis & Clark Exposition and welcomed the National American Woman Suffrage Association (NAWSA) convention to Portland. At the unveiling of the Sacagawea statue, attended by Susan B. Anthony, Lane made a strong demand for women's suffrage and also spoke on his favorite theme, saying that violence against Indians had always been caused by "white people mistreating the Indians who had befriended them." Lane habitually referred to Portland as the City of Roses, and in his speech closing the Lewis & Clark Expo, he called for an annual "carnival of roses," becoming the so-called Father of the Portland Rose Festival.

Allen Rushlight, the eastside plumber who had been one of Mayor Lane's only allies on the city council, succeeded Little Joe Simon as mayor in 1911. By that time, the Progressive-Democrat alliance had elected a governor. Oswald West, of Salem, became governor in 1910 and presided over one of the most progressive eras of politics in the state. The election of 1912 was the high point, bringing women's suffrage along with other reforms. The progressive movement passed many reforms between 1902 and 1916, but it was a mixed bag. The year 1913, the first time women were allowed to vote, brought some of the most radical changes: the first minimum wage law in the country; the eugenics laws, which mandated the sterilization of mentally retarded, some criminals and men convicted of sodomy; and alcohol prohibition, which took effect in 1916.

# LOLA BALDWIN

## *The Day of the Girl*

*The average working girl is lamentably ignorant and innocent of the ways of the tempter, whether he appears clothed in a dress suit or rough homespun.*
—*Lola G. Baldwin*

In 1905, at the age of fifty-four, Portland reached its maturity as a city. Its public birthday party was the Lewis & Clark Centennial Exposition. With a progressive new mayor, Harry Lane, and a national reputation for direct democracy, Portland gained the nation's attention with the Expo. More than 1.5 million people visited the elaborate fairgrounds, built on and around Guild's Lake in northwest Portland, and fully one-third of them were from other regions. An estimated two thousand young single women came to Portland for the Expo; many of them were looking for a new life, a career or a husband. Some of them were just looking for fun. They found it along "The Trail," the amusement section of the Expo, which featured shooting galleries, peep shows, belly dancing arcades, beer gardens and funhouses, such as the Haunted Castle and the Mirror Maze. Police Chief Charles Hunt warned the city of other visitors that would be attracted to the Expo: burglars, pickpockets, grafters and conmen who made their living by robbing the greenhorns. The predators that were attracted by the crowd created a special danger for young women. In the twelve years since the Chicago Columbian Exposition, more than 1,100 young women had disappeared at World's Fairs.

The year 1905 was the beginning of a period that would see an influx of single young women to Portland. They thought of themselves as girls,

The 1905 Lewis & Clark Centennial Exposition brought national attention to the Rose City. More than 1.5 million people visited the Expo; fully one-third were from other parts of the country. Approximately 2,000 single young women came for the Expo and stayed in Portland to find a new life. They were the beginning of a wave of female immigration to the state. Photo by Olaf Indahl. *Courtesy of Old Oregon Photos.*

and they were looking for new lives; Portland presented excellent new opportunities for women. Mayor Harry Lane led the nation in appointing women to public office, but most of the new girls in town didn't find such good opportunities. In 1912, Louise Bryant, writing for the *Oregonian*, told the stories of some of them, using false names to protect their identities. Hilma was a young immigrant from Europe looking for factory work so she could support her widowed mother. She met a man at a dance who offered help, finding a job and an apartment for her in Portland. In return, he expected sex, telling her to keep their arrangement secret. Mabel, a fifteen-year-old girl from Illinois, came to town after corresponding with a Portland man for the purpose of marriage. When she met him, she didn't want to marry him, but she had no way to support herself or get home. The man was persuaded to give her seventy-five dollars for travel, but the inexperienced girl spent all of it on clothes and jewelry. The surrounding rural area provided a steady supply of young men and women sent to the city to "get lost in the shuffle"

by families that couldn't support them. Other girls were from Portland but were neglected or forgotten by their parents.

Two women who came to Portland in the first decade of the new century show different paths that were available as they broke employment barriers and moved into positions that had previously been seen as men's work. Lola Greene Baldwin came to Portland in 1904 when her husband opened the first chain "dime store" in town. Baldwin would soon challenge the Portland Police Bureau's all-male policy and make her mark nationally in the new job of policewoman. She became a prominent leader in the anti-vice and reform movements and an outstanding leader for conservative feminism. Louise Bryant came to Portland in 1909 as a recent college graduate married to Portland dentist Dr. Paul Trullinger. She soon began writing feature stories for the *Oregonian* and other publications, often telling the stories of women who broke employment barriers such as Hildegarde Butz, seventeen, the first female postal carrier in Portland, or Mary Frances Isom of the Multnomah County Library. Bryant would become a nationally recognized journalist. She participated in Portland's vibrant bohemian community and shared its infatuation with radical politics. Through her second husband, Portland journalist Jack Reed, she gained prominence in Socialist Party circles and became one of the newborn Soviet Union's greatest propagandists.

Bryant and Baldwin met when the reporter profiled the policewoman for the *Oregonian* in 1912. Bryant focused on the work of Portland's Women's Protective Division and its success under Baldwin's leadership. Starting with the YWCA'S Traveler's Aid Association (TAA) in 1905, Baldwin assisted thousands of girls and young women who had come to Portland and found themselves in trouble of one kind or another. Baldwin raised funds to keep the TAA going after the Expo closed in October 1905, and she lobbied the city to provide a budget for the Department of Public Safety. In 1908, Baldwin scored 95 percent on a new civil service exam for "female detective" and became Portland's first female police officer and head of the Woman's Auxiliary of the Police Bureau, an agency whose name would soon change to the Women's Protective Division (WPD). Women had been working as matrons, guards for female prisoners, in Portland's jail since the 1870s, but only one female police officer has been identified prior to Lola Baldwin: Detective Sergeant Marie Owens of the Chicago Police Department, who started her career in 1891. By the time Louise Bryant interviewed Detective Baldwin in 1912, the flood of girls to Portland had become a torrent. In 1905, the TAA aided more than 1,600

new female Portlanders; by 1907, the Department of Public Safety was serving nearly 7,000 young women per year.

The WPD provided assistance for young women in all kinds of situations. Baldwin, who wore plain clothes and kept her badge and gun in her purse, and her female staff were called in to assist with crimes involving women or whenever women found themselves in need of help. The WPD provided lodging, food, occasionally transportation and often job training and assistance. About one-third of the young women who came to the WPD for help became employed as domestics in Portland homes. In addition to assistance, the WPD conducted investigations of "traps," such as dancehalls, saloons and rooming houses that often served as gateways to prostitution. Baldwin saw the connection between poverty and prostitution, and she became a strong advocate for vocational training and employment of women, minimum wage and maximum hour legislation and safety regulation of workplaces. Baldwin also became a strong anti-vice campaigner, lobbying for legislation to restrict women's employment in saloons and "immoral" dance steps. She participated in the city's 1912 Vice Commission, which discovered that most of the city's prostitution, despite popular belief, was not confined to the North End but was taking place in buildings owned by some of the most prominent civic leaders. Baldwin was an advocate for what she called "wayward girls," helping to establish the Hillcrest School as a place where "immoral" girls could be confined and given vocational training. She personally sent hundreds of young women to the school. The Hillcrest School for Girls became one of the grievances against Lola Baldwin that made her a target for Portland's radical community.

"I am an anarchist," declared Portland attorney C.E.S. Wood in 1905. Wood had befriended anarchist Emma Goldman when she visited Portland for the first time in 1893. She visited Portland several times between 1893 and 1916, sometimes causing huge controversy, but always hosted and defended by Wood. C.E.S. Wood had become one of the richest railroad lawyers in Portland, and he donated his services to radicals of all stripes. As an advocate for free speech and civil rights, Wood served as the conscience of the city, always reminding Portland of its international role in social justice. He was an artist as well as an attorney, and he encouraged, and often supported, budding poets such as Jack Reed and artists like Portland painter/ceramicist Carl Walters and sculptor Mary Louise Feldenheimer. Wood served as a bridge between Portland's community of artists and writers and political radicals like Goldman, the IWW's Tom Burns and Dr. Marie Equi, creating a fad for radical politics that attracted Portlanders of all classes—especially

Lola Baldwin (center) and her two deputies, Grace E. Fix and Dagmar Riley, provided assistance to more than 1,600 young women who came to Portland for the Lewis & Clark Centennial Exposition in 1905. When the Expo ended in mid-October, the need for the women's services only increased. Photographer unknown. *Courtesy of Portland Police Historical Society.*

the middle. Nina Lane, daughter of the mayor, became one of Portland's leading Socialists; Herman C. Uthoff and Louise Olivereau were Portland's main birth control/sex education activists; Dr. Paul Trullinger, a successful dentist, and his young wife, Louise, were attracted by the glamour and participated on the fringes of the cultural movement.

Louise Trullinger Bryant was twenty years old when she came to Portland in 1909. After growing up in California and Reno, she attended the University of Oregon in Eugene, studying journalism. The young wife found Portland provincial and boring; her favorite name for the Rose City was "that silly old town." She shared a nice home with her husband in northeast Portland, but she kept a studio on Southwest Yamhill Street, where she wrote and painted a little. Her studio attracted Portland artists and photographers, and she became good friends with Sara Bard Field, poet, suffragist and Christian socialist, and Helen Walters, painter and wife of Carl Walters. She began to experiment with free love and other radical ideas. She became a subscription agent for New York's leftist magazine *The Masses*, where Jack Reed had published his dispatches from the revolution in Mexico and gained national fame. Reed was probably pointed out to Bryant, and they may have met when he visited his mother in Portland in August 1914. She remembered him speaking at a rally for unemployed workers at the International Workers of the World (IWW) hall in northwest Portland; the rally was also attended by Emma Goldman and C.E.S. Wood. They wouldn't really meet until the next year, when Reed returned from Europe, where he wrote movingly about the war and the profits it was bringing to conservative business interests.

The IWW had become a center of leftist activity and a gathering place for the bohemian "radical chic" crowd since the Portland local's organization in 1907. Born out of a lumber mill strike, the radical group had become a strong source of cultural resistance. The creativity and the popularity of "Wobbly" music helped to bridge the gap between art and politics and drew crowds of young bohemians. In Elizabeth Gurley Flynn, the IWW's fiery "girl street orator" immortalized in Joe Hill's song "The Rebel Girl," young working women found a role model and a new opportunity. When the mostly female workers of southeast Portland's Oregon Packing Company cannery went on strike in 1913, they immediately gained support from the IWW. In the ensuing free speech fight, dozens of young female cannery workers were arrested for illegal street speaking. They continued their activism in jail, reaching out to the "immoral and wayward girls" they found in the cells. One of them, identified only as Lillian, told her story to striking cannery worker Jean Bennett.

Lola Baldwin pioneered the position of policewoman in the Portland Police Bureau. As a detective, she set patterns that would apply to women on the police force for more than fifty years, such as working in plain clothes and keeping her badge and gun concealed in her purse. She was a sworn enemy of Portland's radical IWW, and they returned the favor. Photographer unknown. *Courtesy of Portland Police Historical Society.*

Lillian came to Lola Baldwin's attention in 1910 after an appeal from the Boys and Girls Aid Society. The fifteen-year-old girl was being neglected by her mother, a recent widow who had become a "fast woman." Baldwin described Lillian as "a bold girl with immoral tendencies and an inclination to be dishonest," but she hadn't committed any crimes and she was placed as a mother's helper in an "estimable private family." When Lillian turned eighteen in July 1913, she left her employment and "immediately became immoral." Lillian is probably not the girl's real name, so it is difficult to know exactly what she did, but most likely she was arrested for being out "after hours" or at a dance hall. Baldwin was waging an intense battle against the city's more than twenty "nickel dance halls," where racy new dance steps, such as the Turkey Trot and the Bunny Hug, were being danced to ragtime music. She, and many other Portland social hygienists, felt the music, the dances and the atmosphere, usually in close proximity to saloons and full of drunken men, severely endangered the morals of young girls. Whatever Lillian did, she was convicted of being incorrigible and sentenced to the maximum: three years in Hillcrest School.

Jean Bennett took young Lillian's story to Portland's working-class *Daily News*, which quoted the radical organizer that the girl was being "railroaded into a slave labor camp." It was not the first public opposition to Lola Baldwin and her policies, but it was the biggest. The IWW brought the case before the State Board of Control, arguing that Lillian was being "wrongfully detained." The female organizers continued their activity in the jails and in the neighborhoods reaching out to young women with their ideas of class struggle and anti-authoritarianism. Baldwin complained that the young women who had come into contact with the IWW were uncooperative, unwilling to take advice and openly defiant of authority. When the State Board ruled against them, the frustrated Wobblies organized a recall petition against Lola Baldwin, claiming she was "heartless and cold blooded and not fit to judge human flesh and blood." Mayor Albee supported his unpopular employee, saying that he "never considered dismissal or even a reprimand for Mrs. Baldwin." The unsuccessful campaign fueled an attack on the school in the legislature the next year, but the Hillcrest School's success in "rehabilitating wayward girls" allowed it to become an Oregon institution for generations.

Lola Baldwin left her mark on the Portland Police Bureau and the city. She helped create the city's first juvenile court, a concept pioneered in Seattle, and served as its first probation officer. She was instrumental in setting up one of the nation's first domestic relations courts to deal with family issues.

She was the role model for female police officers in Portland until the 1970s. Cities around the country contacted Baldwin to learn about the WPD, and they used her methods to set up Protective Divisions of their own with female officers. In 1912, she and Matron Mary Brown of Seattle organized the first national conference of policewomen, which was held in Portland. During the Great War, Baldwin was appointed supervisor of the federal law enforcement division for the Pacific coast. In that position, she helped keep order on military bases and enforced what historian Gloria Myers called "moral martial law." She made contacts all over the west and had great influence on law enforcement in several cities. She may not have been the nation's first policewoman, but she popularized and embodied the idea for a great many Americans.

PART VI

*To the Brink of Revolution*

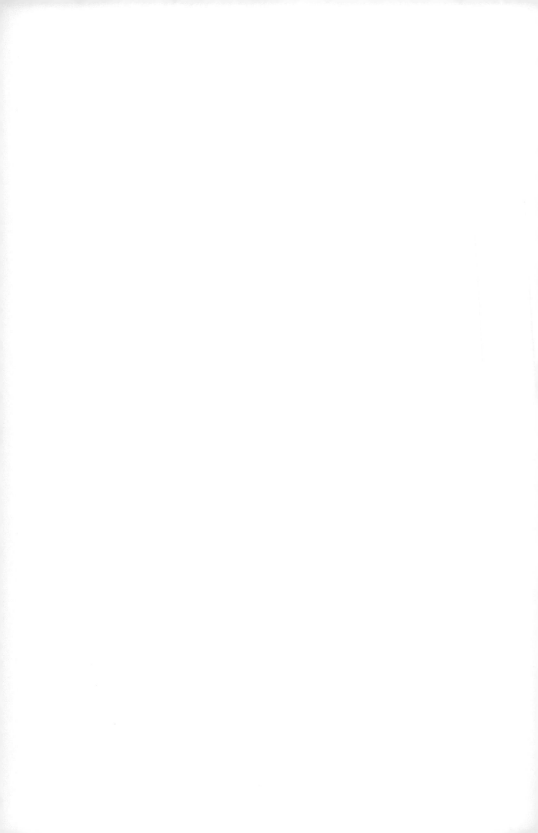

# NO OUTWARD SIGN

*Degenerates are not always common criminals, prostitutes, anarchists, and
pronounced lunatics; they are often authors and artists.*
—Max Nordau

The nature of the economy in the Pacific Northwest, based on extraction of natural resources and dependent on outside sources of capital, made an abundant source of cheap labor a necessity. The need was filled by immigration as thousands of workers from Asia, Europe and other regions of the United States migrated to the northwest. By 1900, more than 50 percent of Portland's residents had been born outside the United States. The boom and bust nature of the American economy, with major financial recessions or depressions every decade or so, combined with the expansion of transportation networks created a large force of migratory workers who traveled the region working in agriculture, lumbering, mining and other occupations. In addition, the Panic of 1893 forced the foreclosure of mortgages all over the state, removing the children and grandchildren of the pioneers from the land their ancestors had settled. Many of them, along with displaced and impoverished Native Americans, joined the transient workforce. Historian Peter Boag refers to the period of 1880 to 1930 as the "Golden Age of the Transient Worker."

Workers raised in Oregon, where public education had been available since the 1850s, tended to have a high rate of literacy, and this migratory workforce became an important source of cultural creativity. This creativity

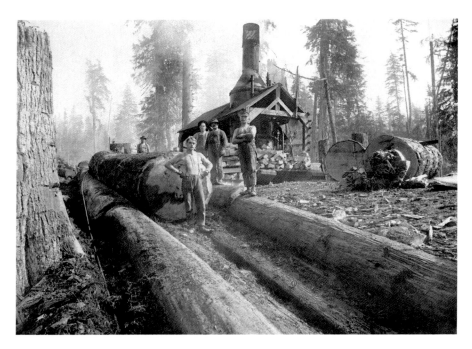

In 1900, more than 50 percent of the jobs in the state of Oregon were associated with the production of lumber. Workers in remote lumber camps lived migratory lives that included unique cultural expressions in language, song and story. Photo by John F. Ford. *Courtesy of Old Oregon Photos.*

was expressed in songs, stories and cartoons, as well as in the use of language. The transient community had an elaborate class structure that was described with expressive language. In the top rank were the hoboes, migratory workers who travelled from job to job by hitching rides on freight trains. Tramps were migratory non-workers, living off of straight society and the migratory workers; tramps were considered to be just one step above the yeggs, who lived by stealing. Bums were migratory workers who had been sidelined by injury, age, illness or alcoholism and settled down on the Main Stem, surviving by begging.

The Main Stem was the street in a city where the migratory community gathered. In the northwest, where most of the jobs were in logging, this street was often the Skid Road, where logs were skidded to the lumber mill. The most famous Skid Road was Yesler Avenue in Seattle, where they were still skidding logs as late as the 1870s. In Portland, the Skid Road was Burnside Street, but it hadn't seen a lot of logging since the Stumptown days

of the 1850s. Burnside, situated near the wide-open North End, bustling Union Station and the busy waterfront was a natural Main Stem. The migrant community, connected by railroad lines to all of the cities, mining towns, farming towns and lumber camps of the West developed an efficient communication system called the "grapevine." The grapevine circulated information vital to the migrant workers such as intelligence on police activity, employment conditions, political theory and the latest songs, stories and satires. Portland connected rail lines throughout the region and became an important hub in the grapevine. In 1905, when the Wobblies, of the Industrial Workers of the World (IWW), started organizing hoboes, Portland became an important center of their activity.

Among the migratory workers, especially those who worked in remote locations such as lumber camps and mines, same-sex sexual activity was very common. While it is impossible to tell how many men participated in this activity, estimates run the range from seventy to ninety percent. Most men saw same-sex encounters as a substitute for sex with women who were not available. According to Alfred Kinsey's 1948 report on American sexual activity, the highest incidence of homosexual activity occurred in the most remote locations; such as the work areas of the migratory workers of the Pacific Northwest. It also became clear from Kinsey's study that a significant percentage of men prefer sex with other men and are not attracted to women at all. Among the migratory workers it was common for mature men and young boys to pair up in relationships to provide protection and sex while travelling. In the expressive language of the hoboes, the participants in these relationships were the Jocker, older partner, and the Punk, younger. There were also Wolves, who preyed on younger boys, Chickens, and used coercion as part of their sexual technique; and the Fairy, who was a man who identified as female and became a common stereotype of gay men. In addition, there were a percentage of transgendered women who dressed and lived secretly as men.

On the Main Stem, some of the Punks who arrived in town remained as sex workers. Places like the Monte Carlo Poolroom and the Fairmont Hotel on Northwest Sixth between Burnside and Couch became notorious for male prostitutes; some of them even dressed as women, becoming the first visible transgender community in Portland. Most Portlanders understood homosexuality as a symptom of degeneration, caused by the decay of civilization in the theory of Max Nordau. Since the working class was already a degenerated class, it was assumed that they would indulge in "unnatural acts." Like most vices in Portland, as long as it wasn't too visible,

it was allowed. If behavior ever became too blatant, the laws were there to be enforced. A man convicted of sodomy could be imprisoned for two to five years; attempted sodomy could bring a term of as much as two years. The Oregon State Penitentiary confined many men for these offenses. In 1913, the Eugenics Laws allowed the state to castrate men for the crime of sodomy. That law remained in effect until the 1960s.

South of Burnside, another economic reality was creating a middle/professional-class gay community. Between the 1880s and the 1930s, corporate capitalism was becoming dominant, displacing the small employer and owner/operator capitalism that dominated Portland, especially on the eastside. East Portland, which had merged into the city in 1891, grew as a working-class district; housing the less migratory labor force. The increasingly class-conscious population was made up of wage workers and small employer/owner operators who found themselves united in the labor movement and the Populist/Progressive movement against the spread of corporate capitalism. Corporate capitalism dominated west Portland, the original city, well before the twentieth century. The constant demand for clerks, bookkeepers, auditors and other white collar workers created a class of educated, male office workers; a percentage of them were attracted to same-sex partnerships.

Because of the social stigma involved with homosexual activity, it occurred clandestinely, often between married men. The public restroom at Lownsdale Square in the Plaza Blocks and the men's room in the basement of the Imperial Hotel on Southwest Washington were among the earliest spots where these assignations were conducted. The Plaza Blocks, across the street from city hall and the Multnomah County Courthouse, were a traditional gathering spot where street oratory, music and missionary work of all kinds was conducted. Chapman Square, across from the City Hall, was typically reserved for women and children; Lownsdale Square was for men. In 1923, a city ordinance institutionalized these traditions. The community of young single men employed downtown clustered in apartments on Southwest Washington and at the YMCA on Southwest Yamhill. By 1910, a complex gay community existed in this area, with gay-owned businesses such as the ABC Restaurant, owned by Claude Bronner, and the Smart Shop Millinery Store, owned by E.S.J. McAllister, openly recognized as gay-owned by other gays but disguised from the public. Secret code words and clothing cues, such as wearing a green suit, were used to identify and make contact with others interested in same-sex encounters.

After logging, ship building was the next-largest employer in the city. The less migratory working class of Portland settled on the eastside in neighborhoods that became radicalized and politically active as they fought against the spread of corporate capitalism. Photographer unknown. *Courtesy of Old Oregon Photos.*

The Young Men's Christian Association (YMCA) began in Portland in 1868 with the goal of providing a moral atmosphere for young men to exercise. As the influx of young men to the city increased, the YMCA began to offer lodging at its building on Southwest Fourth and Yamhill. In 1909, the organization moved into its new building two blocks away, and many men who worked downtown took up residence. William S. Ladd had been one of the original founders of the YMCA in Portland, and it had always received a great deal of support from the city's establishment. In 1909, William M. Ladd became president of the YMCA Board. When the so-called Vice Clique of 1912 was exposed, along with its connection to the YMCA, the organization came under attack. The connection through Ladd and others to the city's establishment made it a good target for journalists such as Dana Sleeth of the *Portland News*, who wished to advance their class-war agendas. The scandal changed the way Portlanders understood homosexuality, for the

first time defining a person by his sexual preference as a homosexual. The backlash from the scandal created a severe repression against homosexuals that continued well into the 1980s.

Besides the political and social implications, the scandal destroyed lives. Dr. Harry Start, who was first convicted and first to have his conviction overturned, went into exile in China, and his abandoned wife, Mabel, drank herself to death while hiding from debtors in her Irvington home. William H. Allen, a Spanish American War veteran and clothing store clerk, killed himself in shame. Claude Bronner, a restaurant owner, spent several years in jail even though he testified against his friends. Of these men, E.S.J. McAllister, a prominent attorney, had the most to lose.

Edward Stonewall Jackson McAllister was born in Delaware in 1869. He completed his law degree in 1904 at the University of Virginia, settled down with his wife and was admitted to the bar. In October 1904, McAllister moved to Oregon without his wife and lived as a single man in downtown Portland. It was a good time for a politically active Democrat to come to Portland; Harry Lane would soon be elected mayor. McAllister threw himself into the political scene. He was hired as legal counsel for the Anti-Saloon League's (ASL) Southern Oregon and Idaho department. He led the fight to defend Oregon Local Option alcohol laws, which had recently been adopted. The ASL position took McAllister all over the state, and he made political enemies everywhere. In Portland, he became a powerful ally of William U'Ren and the People's Power movement in the fight for the Single Tax. McAllister became president of the People's Forum in 1906. The organization dedicated to political education and debate included such powerful activists as Abigail Scott Duniway and C.E.S. Wood. He had a promising future in the progressive Democratic Party that was changing the shape of government in the country—until his sexual relationship with Roy Kadel was publically revealed. His conviction for sodomy was overturned on a technicality, but his political enemies made sure that his name was smeared and his future destroyed. He retired to Myrtle Creek in rural Douglas County and lived the rest of his life in obscurity.

A few months after the Vice Clique Scandal, another arrest exposed the working-class homosexual community. Mayor Albee had been under great pressure to do two things: repress vice in the North End, and repress the organizers of the IWW, who were agitating cannery workers on the east side. Acting police chief Enoch Slover saw an opportunity when he received a tip that "Greeks" were engaging in illicit sex at the Monte Carlo Poolroom in the North End. Detectives Craddock and Goltz staked out the poolroom

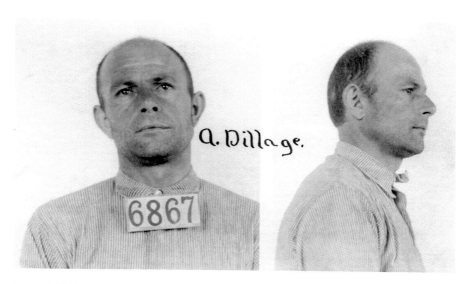

In April 1913, Andrew Dillage, a migratory worker from Greece, was arrested with a young man at the Fairmont Hotel. Convicted of attempted sodomy, he spent fifteen months in prison. Police cracked down on homosexual activity among foreign-born workers as a way to put pressure on the IWW. Photographer unknown. *Courtesy of Oregon State Archive Inmate File #6867.*

and hauled in five young men who confessed to prostitution and implicated several men as their clients. On April 18, they followed nineteen-year-old Grover King to the Fairmont Hotel with thirty-five-year-old Andrew Dillage, a migrant laborer originally from Greece. The two detectives broke into room 29 and caught the two men in bed preparing to have sex. Dillage was convicted of attempted sodomy and spent fifteen months in the Oregon State Penitentiary. King, who may have been cooperating with the police, was charged with vagrancy, and the charge was dropped. The so-called Greek Scandal was used to whip up anti-immigrant sentiment just in time for the cannery strike that would increase tensions with the IWW.

# SULPHURIC ELOQUENCE

## *Dr. Marie Equi and the Wobblies*

*A fact is harder to prove than a fiction.*
—*Sam Murray*

Marie Equi was born in Massachusetts in 1872, the daughter of an Italian stonemason and an Irish homemaker. Her mother was an implacable enemy of the English, and her father was an anti-monarchist and labor activist with the Knights of Labor. From her parents, she learned to stand up against injustice. At the age of eight, she began working in a textile mill and had an opportunity to see injustice firsthand. Working conditions were primitive: dirty, poorly lit, with little or no ventilation, and workers, mostly girls under sixteen, were often locked into the factory for ten to twelve hours per day. At the age of thirteen, Equi developed tuberculosis and spent a few years with her grandparents in Italy while she recovered. Although she got over tuberculosis, her health was always a bit fragile, and she spent the last thirty years of her life as a semi-invalid.

She returned to the United States in 1889, at the age of seventeen, and began to make plans to move west. Equi developed intense friendships and love affairs with other women throughout her life. Sometime after 1890, she and Bess Holcolm moved to The Dalles, on the Columbia River. Holcolm had been hired as a school teacher at the Wasco Independent Academy (WIA) and the two women lived in what was known as a "Boston Marriage." In 1893 a dispute over Holcolm's pay inspired Equi to her first direct action. She confronted the WIA president, Reverend O.D. Taylor, and beat him with

Dr. Marie Equi graduated from University of Oregon Medical School in 1903. Active in the suffrage movement, she was radicalized by the strike at the Oregon Packing Company, which involved many of the young immigrant women who were her patients. Photographer unknown. *Courtesy of Oregon Historical Society* OHS BB002610.

a horsewhip. Newspaper reports were admiring of the young woman, called "The Dalles Sensation" by the *Oregonian*, and her action was popular in The Dalles. Reverend Taylor still refused to pay Holcolm the money that was in dispute, but the townspeople auctioned off Equi's horsewhip and raised enough money to not only pay the young woman's fine but also the disputed $100 dollars.

During her long recovery from tuberculosis, Equi developed an interest in medicine and was determined to become a doctor. In 1900, only 3 percent of doctors in the country were women, but in Oregon the percentage was 9 percent, partly because of the influence of doctors like Bethenia Owens-Adair. The University of Oregon Medical School was located in Northwest Portland, on the spot where the Good Samaritan Hospital is currently located, from 1892 until 1919. Marie Equi graduated from medical school there in 1903, two years before the school's first female graduate, Dr. Esther Pohl Lovejoy, was appointed to the city Board of Health.

Dr. Equi set up practice in the Medical Building on Southwest Alder near Park Street and moved into the Nortonia Hotel (now the Mark Spencer) a few blocks away. Her new partner, Harriett Speckert, was the heiress of a wealthy brewer from Butte, Montana. Equi and Speckert were open about their relationship and often in the public eye. In 1907, they competed in the Class A Carriage and Team competition at the first official Rose Festival, where they took second place. The two women even adopted an infant girl together, Mary Equi, who later became the first female pilot in

Oregon. Dr. Equi specialized in women's health, and most of her patients were young working women, many of them immigrants. She performed abortions for women of all classes, although the procedure had become illegal in 1890 and had never been socially acceptable. She was open about the services she provided and protected herself by performing abortions for police officials and then holding the knowledge over their heads. When she and George H. Prettyman, a special deputy of the Multnomah County sheriff, came to blows, Dr. Equi defended herself with a pistol. After calling the police, she threatened to expose the fact that she had performed an abortion for a young woman brought to her by the deputy, "who should be ashamed of himself."

Dr. Equi was politically active, speaking on women's health issues during the National American Woman Suffrage Association (NAWSA) convention in 1905. She became very active during the suffrage campaigns of 1906 and 1910. In 1906, she led the recovery effort after the San Francisco earthquake. At one point during the relief effort, she came under U.S. Army authority and became the first woman to achieve the rank of doctor in the army. By the time the Suffrage Amendment finally passed in 1912, she was an important part of the campaign and a strong ally of Abigail Scott Duniway. Marie Equi had a powerful voice and an even more powerful will. She could not be shouted down in meetings, and she often took the most radical stands. She had a very hot temper, and in the heat of the moment, she could say or do almost anything. She carried a pistol with her most of the time and wore long hatpins in her hair; she relied on both weapons for defense when she felt physically attacked, even by the police.

Many of Dr. Equi's patients were young women who worked in canneries on the eastside. For example, the Oregon Packing Company (OPC) on Southeast Belmont employed about two hundred women in 1913, the majority of them between the ages of twelve and twenty and many of them students at nearby Washington High School. The cannery specialized in fruit, and its heavy season was the summer. The women would work ten- to twelve-hour days seven days a week for less than ten cents an hour, being paid at a piece rate. Conditions were bad with old machinery and no sanitary or safety regulation. The doors were often kept locked—even when the heat soared—to keep the workers on the job and union organizers on the street. Dr. Equi took an interest in the young women and their lives, especially a young Native American woman known only as Mrs. O'Connor who came to her in the early stages of pregnancy. Dr. Equi provided prenatal care for the young woman and learned about the conditions at the eastside cannery.

The Portland local of the Industrial Workers of the World (IWW) was interested in conditions at the OPC cannery as well. The IWW had organized in 1905 in response to the bloody labor violence of the 1890s. The IWW was a revolutionary labor organization committed to ending the capitalist system of wage slavery by organizing workers in all industries and creating a General Strike in which the workers would take control of not only their workplaces but also the government itself. The IWW organized workers of all races and genders, unlike the segregated, all-male American Federation of Labor (AFL) unions that dominated the movement at the time. The organization used sabotage, in which workers slowed down production by inefficiency or following rules to ridiculous lengths; strikes; and street demonstrations known as Free Speech Fights as its tactics. Cultural resistance in the form of songs, graphic art, cartoons and slogans was the group's main tool. Workers faced violent opposition from employers and government wherever they went, and many IWW organizers were killed or framed on serious criminal charges.

The Portland local had organized in 1907 during a strike at the Eastern and Western Lumber Mill. Many talented musicians made up the membership, including J.H. Walsh, Pat Kelly and Harry "Haywire Mac" McClintock. In 1908, the Overalls Brigade, a twenty-member singing group, marched, rode the rails and sang their way to the national convention in Chicago. Dressed in black overalls and shirts with bright red neckties, they rallied the forces for union organizing over political action with Pat Kelly's song "Hallelujah, I'm a Bum." The organizing side won, and from that year, the IWW rejected politics as a revolutionary activity. When they returned to Portland, the Overalls Brigade produced the first *Little Red Songbook*. The collection of revolutionary songs would become the IWW's most lasting contribution to the labor movement. Joe Hill, the IWW's famous martyr who was killed in 1915, came to Portland to introduce his song "The Preacher and the Slave." The song, among Hill's most memorable, satirizes religion and coins the phrase "pie in the sky." It was performed in public for the first time in Lownsdale Square in November 1910.

Lownsdale Square, along with Chapman Square and the Elk statue in the middle of Southwest Market Street, was a part of the Plaza Blocks and had become the traditional spot for street oratory. On any given day, it was possible to find speakers on all topics of a political or religious nature orating from soapboxes and stools. Wobblies, as the IWW members were called, were a regular fixture of the park, and their music gave them an edge that could be used to drown out other speakers. Tom Burns, who would come

Joe Hill came to Portland in 1910 to introduce his song "The Preacher and the Slave." He went on to write dozens of "songs of discontent" and became an international symbol of labor organizing and solidarity after his death in 1915. Photographer unknown. *Courtesy of U.S. Library of Congress.*

to be known as Portland's most frequently arrested man, was known for his loud voice and fiery rhetoric. Wobblies had a reputation as dangerous radicals, and many workers were afraid to talk with them, but to those who did, they seemed to be the only hope for improving their condition.

In July 1913, the women of the OPC cannery walked out of the plant on strike. They demanded nine-hour days, $1.50 per day in wages and overtime pay for Sunday. The employer locked the doors and refused to negotiate, but with fruit rotting, it needed to get the plant operating again or suffer a huge loss. A local religious group negotiated a wage of $1 per day and a guarantee of no more than ten hours a day, agreeing to the deal without consulting the workers. A reduced staff went back to work, and the locked-out workers, along with IWW organizers and supportive local residents, took to the streets. The strikers kept up street demonstrations and pickets while the plant was in operation. In the evenings, they marched

across the bridge and held rallies at the Elk fountain or at the corner of Southwest Sixth and Washington. Dr. Equi attended the rallies and was often a fiery speaker.

Newly elected mayor H. Russell Albee was sensitive to labor issues, but he knew that his predecessor, Allen Rushlight, had been severely criticized for not taking a hard line with the IWW. Albee held public meetings in which he questioned workers, strikers and company managers and then imposed restrictions on street speaking, limiting it only to the Plaza Blocks and ordering Sheriff Tom Word to enforce the ban strictly. The IWW had become famous for its free speech fights in which Wobblies from all over the country would converge on a city to challenge restrictions on street speaking. Their strategy was civil disobedience, filling the jails by submitting to arrest. There had been major free speech fights in Spokane, Fresno, Oakland and many other towns. In 1913, it was Portland's turn.

On July 15, a group of strikers marched across the Morrison Bridge from the OPC factory, gathering at the corner of Southwest Sixth and Washington. The *Oregonian*, a notoriously anti-IWW paper, said there were several hundred people gathered there when, shortly after 9:00 p.m., Tom Burns mounted a soapbox and began his speech. At one point, Tom Burns said, "We will fly the red flag of anarchy over the marble palace up there," gesturing toward city hall several blocks away.

As if those words were a signal, Sheriff Word gave the order, and Deputy Frank Curtis pulled Burns off the soapbox, arresting him. IWW tactics were to force the police to arrest as many as possible, an effective civil disobedience tactic. As soon as Burns was pulled off the box, Rudolph Schwab, a cannery worker and strike leader, took his place. Word and five deputies, along with a dozen PPB patrolmen moved forward, arresting the speakers one after another. After Schwab, Mrs. O'Connor, who also worked at the cannery took his place and was hauled off by the police. Ten strikers were arrested, and then Sheriff Word picked up the box and ordered the streets to be cleared.

Marie Equi identified the brutality she witnessed as the police cleared the streets with their billy clubs, and especially the arrest of pregnant Mrs. O'Connor, as a turning point for her. She followed the police all the way to the station, hurling verbal abuse as she went. When they reached the police station, Equi forced her way inside, striking two police officers with her fist. She convinced the police to release O'Connor, and then she demanded to see Burns and the other arrested strikers. After being physically thrown from the building, she forced her way back inside and harangued the sheriff and

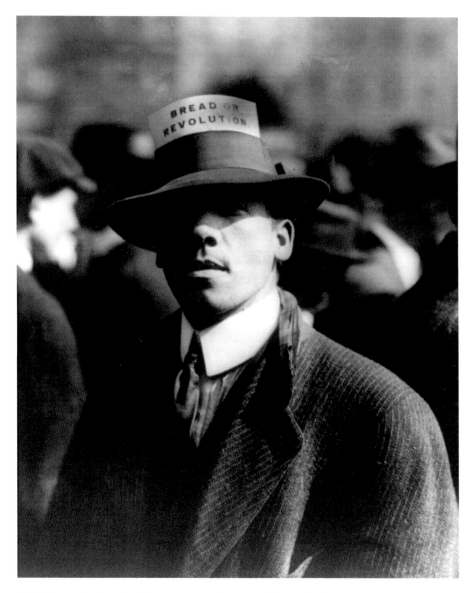

Wobblies used cultural resistance as a regular organizing tactic. Through songs, graphic art and well-crafted slogans, they brought their message of revolution to the masses and challenged the system of wage slavery that they were committed to abolishing. Photographer unknown. *Courtesy of U.S. Library of Congress.*

the city jail guards for more than an hour with what the *Oregonian* called "sulphuric eloquence."

The strike and the free speech fight went on through August, but by then, the season was over and the employers had diverted much of their business to their cannery in Salem. Most of the strikers were left to find other jobs. The Recession of 1913 aggravated the problem, and the IWW began to organize unemployed workers in Portland. Dr. Equi was arrested a few days after the "riot" of July 15, and the prosecutor offered to drop charges if she would commit herself to an insane asylum or leave the state. Her friends, including attorney C.E.S. Wood, pressured her to take a trip to California, and she made it all the way to Union Station before turning back to face charges of inciting a riot and disorderly behavior. She was acquitted but then was seriously injured when she was trampled by a mounted policeman at another demonstration.

Despite her injury, Marie Equi became a leader in the unemployed workers movement and an important ally of the IWW. In 1916, when she heard about Bloody Sunday in Everett, Washington, where more than seven people were killed and nearly fifty injured in a shooting between IWW members and police/vigilantes, she rushed to the scene, providing treatment for the wounded. She became famous for her fiery street speaking, facing arrest several times. When the Great War began in 1914, she violently opposed the war. She made several anti-war speeches in Portland and in 1916 burned an American flag in protest. After the U.S. entered the war, Congress passed Espionage and Sedition Acts that seriously infringed the right of free speech. Portland saw several prosecutions under these laws, some of them extremely frivolous. Dr. Equi was charged with sedition for anti-war statements she had made. Her trial started two days after the war ended, and ex-governor Oswald West, an old friend of hers, testified on her behalf. She was convicted and sentenced to more than three years in prison.

President Wilson shortened her sentence, but Equi served nearly a year in San Quentin. She became a strong advocate for female prisoners and provided medical attention to many of them while in prison. It was a very introspective time for Dr. Equi, and she questioned her motives and her actions while she was there. In her letters to friends, she spoke of her "queerness" and wondered if there was something wrong with her. A good friend replied, "You are perfectly sane, perhaps unusually out of the ordinary," urging her not to try to change herself. According to historian Nancy Krieger, the events in Portland in 1913 made Equi perceive the present as history and understand that history and politics are expressions

of class struggle. This understanding led her to believe that a person could change history, informing her activism for the rest of her life.

Dr. Equi returned to Portland in 1921 and continued her medical practice. She spent the last few years of her life caring for her own health, as she suffered from heart disease, and the health of her close friend Elizabeth Gurley Flynn, the Rebel Girl of the IWW. The two women lived together for more than a decade in a small house in the west hills. During the bloody dock strike of 1934, the two radical old women came out of retirement long enough to show solidarity with the striking longshoremen and donate $250 to the cause. When the Portland Police Bureau issued a "Red List" in 1934, Equi was incensed that her name was not on it. She called Police Chief Harry Niles and threatened to sue the Police Bureau if her name was not put at the top of the list. Flynn went on to be active in the American Communist Party and serve her own jail term in the 1950s. Dr. Equi remained in retirement until her death in 1952 at the age of age of eighty, during another Red Scare.

# STEWART HOLBROOK

## *Inventing Working People's History*

*A long memory is the most radical idea.*
*—Sarah Sparks*

In 1913, during the so-called IWW Riot, veterans of the Spanish-American War and the Philippines Campaign had organized themselves as vigilantes to protect the Oregon Volunteers memorial in Lownsdale Square, which they felt was threatened and dishonored by the rhetoric of radical speakers who liked to climb on the statue to get above their audience. Later, they "assisted" the police in Sheriff Word's brutal street clearings. This is not the first use of military veterans as anti-labor shock troops, but it is an early indicator of a trend that became prevalent during and after the Great War. Returning soldiers formed new veteran's organizations to lobby for their interests. The Veterans of Foreign Wars (VFW), formed by veterans of the Spanish-American War, and the American Legion (AL), formed by Great War veterans, were the two most prominent and lasting. The AL gained the most popularity in the Pacific Northwest and was the most militant.

The IWW was targeted for destruction by northwest employers and the Federal government. In 1917, an IWW-organized strike among loggers paralyzed the lumber industry just as the United States was entering the Great War. President Wilson took over the logging industry, drafted the striking workers and used soldiers to force them back to work, violently suppressing IWW organizers and charging them under anti-Syndicalism laws. With its powerbase in the lumber industry drafted or jailed, the

The Red Scare and suppression of radical unions, accompanied by improving economic and work conditions eroded support for labor unions during the 1920s. In the 1930s, the economic downturn radicalized many workers, and the Communist Party became popular through its support of labor organizing. Photograph by Ralph Eddy. *Courtesy of Old Oregon Photos.*

weakened union, accused of treason against the war effort, went on the defensive. Most Wobblies were advocates of nonviolent passive resistance, but there was a cadre committed to violent revolution and many more who believed in self-defense.

Self-defense was a dangerous proposition for Wobblies. In 1916 at Everett, Washington, when a group of striking mill workers defended themselves from attack by a vigilante group, five of them were killed and several wounded. During the war and the Red Scare that followed, IWW offices all around the country were looted by mobs. During the first Armistice Day parade in Centralia, Washington, on November 11, 1919, Portland IWW member Wesley Everest and a group of Wobblies attempted to protect their office from attack by a group of veterans. Four veterans were killed and five wounded. Everest was lynched by a hostile mob, seven Wobblies were convicted of second-degree murder and Deputy Sheriff John Haney was killed by a trigger-happy posse member.

Brutal repression by the AL and its partner organization, the Ku Klux Klan (KKK), suppressed support for the labor movement among lumber and dock workers during the 1920s. Social and technology advances played their role as well. More and more loggers were able to get to the lumber camps in their own cars, breaking down old migratory patterns. Recognition of a "company union," the Loyal Legion of Loggers and Lumbermen (4L), and government regulation created better working conditions; anti-homosexual propaganda and social repression contributed to the breakdown of the migrant workers' counter-culture. The new generation of workers, many of them veterans themselves, lived in town instead of in lumber camps, commuting to their jobs and identifying themselves with the workers and small business owners who lived in their neighborhoods. Government-sponsored fear campaigns, such as the Palmer Raids, in which hundreds of immigrants deemed "politically subversive," like anarchist Emma Goldman, were rounded up and scheduled for deportation, eroded the support of the socialist movement. The political activity of the newly organized Oregon KKK siphoned off Populist support into racist campaigns, such as its Public Schools Initiative of 1922.

Stewart Holbrook, a Great War veteran, "retired" from a British Columbia logging camp in 1923 to move to Portland because it had the "finest library in the west" and began his writing career. For the rest of his life, Holbrook worked as a freelance writer, starting his career as the editor of the *4L Magazine*, the official organ of the lumber industry labor union. The union was described by Holbrook's friend and fellow writer James Stevens as "a petting party between the lumberman and his employees." Holbrook probably shared the ironic view of his job, but it allowed him to travel to lumber camps all over the northwest collecting stories and reminiscences of loggers and other forest workers. Soon he was selling stories in national and regional magazines, such as *Sunset* and the *American Mercury*. In 1928, he began writing for the *Oregonian*, contributing regular columns and freelance pieces to the newspaper for the next thirty-five years.

Holbrook had no political agenda; he was cynical about politics and didn't like to join organizations, but he had a great interest in the history of working people. He felt that most history that was being written at the time was for "stuffed shirts" and gave a skewed view of the past. He dedicated his life to collecting the stories of workers, political activists, bums and eccentrics in an attempt to create a "lowbrow" history of the United States. Holbrook relied on the reminiscences of sources such as Tom Burns, Portland's most arrested man and Wobbly organizer who had opened a clock shop/radical

The economic crash of 1929 brought hard times to Portland. Growing numbers of unemployed workers gathered in shantytown Hoovervilles like this one near the Ross Island Bridge. Photograph by Ralph Eddy. *Courtesy of Old Oregon Photos.*

lending library on West Burnside and Second and become known as the "Mayor of Burnside," and Edward "Spider" Johnson, who had been a bartender at Erickson's saloon, which claimed to have the longest bar in the west. Collecting their stories over drinks, Holbrook pioneered the technique of oral history, but he repeated stories that were sometimes more legend than fact. Especially when dealing with colorful characters such as Joseph "Bunko" Kelley and Harry Tracy, Holbrook attempted to debunk the myths that had grown around them but ended up perpetuating new ones. Holbrook's histories are full of legend and myth, but the stories are based on fact. They have the power of the storyteller behind them, and they are fun to read.

The Great Depression hit Portland hard and early. By 1927, agricultural prices had dropped to new lows and Oregon's second-largest industry went into decline. Lumber, the largest industry in the state, was also in trouble. The failure of lumber companies and unethical collusion between business and bank managers led to the collapse of the Northwestern National Bank.

The run on the bank on March 28, 1927, created panic in the city, but it was only the first in a long line of bank collapses. By 1931, one-third of America's banks were out of business. The combined resources of U.S. National Bank and Portland's First National Bank, along with piles of cash flown in from Spokane, Seattle and San Francisco, stopped the panic in Portland. It was only temporary, though; after the stock market crash in 1929, there was no stopping the destruction. By 1932, U.S. National Bank had lost 80 percent of its value, and the First National had laid off 20 percent of its employees.

In 1932, Franklin D. Roosevelt, on a campaign stop in Portland while running for president, said, "Only a foolish optimist can deny the dark realities of the moment." Reality included 25,000 unemployed Portlanders and more than 100,000 depending on relief that the city could no longer afford. Thousands of people had lost their homes and lived in "Hoovervilles" that had sprung up around town. Workers who had been apathetic through the 1920s were radicalized by the economic hard times. Protest movements, such as the Bonus Army and the Unemployed Workers Union, sprang up in Portland. When Roosevelt was elected in 1932, the New Deal attempted radical ways to bring relief for poverty and kick-start the economy.

Portland and Multnomah County had experimented with public job programs, relief and scrip in the darkest days of the Depression, but the New Deal brought major changes. Massive public works projects such as the Bonneville and Grand Coulee Dams on the Columbia and Works Progress Administration (WPA) projects such as Timberline Lodge and the Oregon Writers Project not only provided work for thousands of people, but they also prepared the region for the industrial development that would transform the area in the forties and fifties. Stewart Holbrook found work with the WPA, editing the Oregon Writers History Project. Editing two million words on Oregon history gave Holbrook the experience and confidence he needed to begin writing books. In 1938, he produced *Holy Old Mackinaw: A Natural History of the American Lumberjack*; he said he had been waiting for someone to write a history of logging and had finally given up and written it himself.

The book was a compendium of oral histories, exhaustive research and Holbrook's personal experience in lumber camps from Vermont to British Columbia. It was a bestseller, surprising the publisher as much as the author, and Holbrook's career was launched. Over the next two decades, Holbrook wrote twenty books, mostly on history. His books focused on the history of working people and forgotten stories. He had a great sense of humor, and he delighted in poking sacred cows. By 1943, when Holbrook moved back to Portland after being in New England for a few years, he was the most

The Works Progress Administration (WPA) and massive construction projects, such as the Bonneville Dam, created jobs and eased the worst effects of the Depression. Photo by Lee Russell. *Courtesy of U.S. Library of Congress.*

famous writer in the region, and he was treated like a celebrity. Holbrook loved his fame, and he took advantage of it to play practical jokes, such as his collection of satirical paintings, supposedly painted by an acquaintance named Mr. Otis. Holbrook was a working writer for his entire career, dependent on saleable pieces and deadlines. This experience influenced his history, and he always wrote what his readers wanted. He debunked legends and created new ones, making Portland's history a source of entertainment. By popularizing history and focusing on hidden and forgotten stories, Holbrook preserved Portland's past and inspired generations to look deeper and ask: why?

# SOURCES

The local newspapers available in electronic archives through the Multnomah County Library have been the main source for this book. In addition, I have done a great deal of reading about the history of Portland and Oregon. A complete bibliography is available online at http://portlandhiddenhistory.blogspot.com/2013/09/bibliography.html.

# ABOUT THE AUTHOR

JD Chandler lives and works in Portland, Oregon. At one time or another, he has worked as a busboy, waiter, door-to-door salesman, laborer, landscaper, soldier, intelligence analyst, Russian linguist, bellboy, insurance salesman, telephone solicitor, apartment manager, newspaper deliverer, political activist, campaign fundraiser, executive director, in-home caregiver, union organizer, Spanish interpreter, temp, truck driver, account executive, admissions rep, tutor, freelance writer and GED examiner. He has always been a writer. You can read more from him at www.portlandcrime.blogspot.com and www.weirdportland.blogspot.com.

©2013 by Jacqueline Lawson.